Introduction

As you walk through the entries of what is now left of Atherstone's yards, you are sure to notice some antiquated remnants of the town's past, where local trades, industries, and inhabitants coexisted side by side.

The mile-long road on Watling Street (now Long Street) was the town's main thoroughfare, where merchants went about their business and travellers rested overnight in the coaching inns.

Burgage tenements began to develop on Watling Street as far back as the thirteenth century. 'This early town planning gave plots of land of equal size to tenants who were free from customary agricultural service to the manor, and thus were able to concentrate on developing trade...records show that in 1294 there were thirty-six free tenants in the manor' (J. L. Slater *et al.*, 1985). Many trades were developing in Atherstone by the sixteenth century, the emphasis being to provide food, warmth and clothing for the town's population. The seventeenth-century market catered for many different trades, including tanners, brewers, corn and seed merchants, shoemakers, glovers, cutters, ropemakers and saddlemakers, with butchers and bakers trading on either side of the marketplace, hence the previously named Butchers Row and Bakehouse Lane which are now named Market Street and Church Street respectively. The old tenements eventually became retail shops.

A 1766 plan of Long Street (Watling Street) and the marketplace shows a further increase of burgage plots, starting from no. 1 at the station end of Long Street, and continuing up and across to the opposite side of the street, down to no. 120, situated opposite no. 1 and belonging to Hannah Austin. Inhabitants were living and working in the yards that had developed behind the inns and businesses on the front of the main street. Coal mining at Baddesley Colliery, and hatting in the town centre, had become the two main industries in the area. An increase in the number of hat factories using steam power in the nineteenth century for felt hatmaking – for which Atherstone became famous – created even more density and overcrowding in the town centre, when hurriedly built dwellings were erected to accommodate a rapidly growing work force. The 1930s national slum clearances and growing concerns about Atherstone's own poor housing problems, prompted the council to purchase land off private land owners and begin the demolition process of the old dwellings in the town's yards. New council housing estate developments began to take shape from the 1930s to the 1950s.

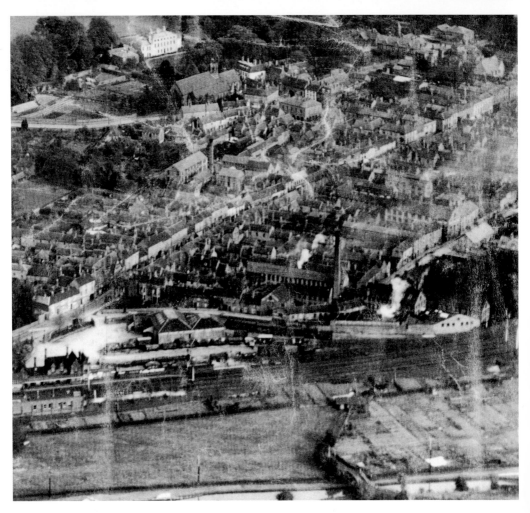

Unfortunately some of Atherstone's prominent buildings were demolished in the 1960s such as the Market Town Hall and Atherstone Hall along with other large establishments. Modern times have altered the face of many shop fronts and businesses. The architectural designs of the buildings though are still distinguishable when comparing with old photographs. Private developments of modern houses and apartments have been built since the millennium in the town centre, on land where some of the demolished yards once stood. Today, there are no little 'yard' communities standing outside – chatting and passing the time of day with one another, children playing games such as 'whip and top', nor a hipbath, bucket, washing line or even a broom in sight. Atherstone still does however have a close knit community, and the centuries-old Market Town still retains its quaintness and charm – in the heart of some of Warwickshire and Leicestershire's beautiful landscapes.

Christine Freeman

ATHERSTONE

THROUGH TIME

Christine Freeman

AMBERLEY PUBLISHING

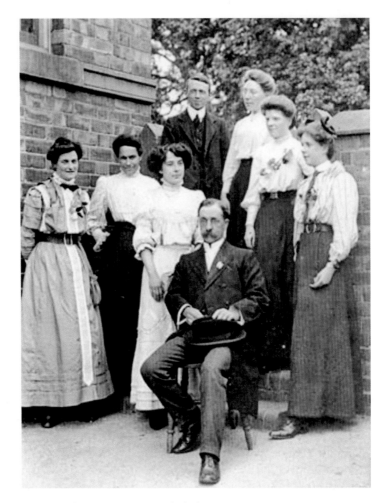

(Photograph: W.C.R.O. PH 352/14/32)

To My Family xx

First published 2012

Amberley Publishing
The Hill, Stroud
Gloucestershire, GL5 4EP

www.amberley-books.com

Copyright © Christine Freeman, 2012

The right of Christine Freeman to be identified as the
Author of this work has been asserted in accordance
with the Copyrights, Designs and Patents Act 1988.

ISBN 978 1 4456 0714 6

British Library Cataloguing in Publication Data.
A catalogue record for this book is available from
the British Library.

Typeset in 9.5pt on 12pt Celeste.
Typesetting by Amberley Publishing.
Printed in the UK.

Acknowledgements

I would like to thank the following people most sincerely for giving up so much of their time and supporting me while I have been compiling *Atherstone Through Time*.

Roy Allitt – A local photographer who has taken many of the modern photographs for this publication and also loaned photographs from his own collection. Dr. Alan Barnes – another reliable friend, who has proof read my material and also allowed me to reproduce some of his late father's (Mr Sidney Barnes) photographs. Graham Beale – A local photographer who has kindly loaned images from his own personal collection called 'Atherstone's Events'. Atherstone Library – Gail Zur, Cath Hughes, Leslie Kirkwood and all of the library staff who are always most helpful.

I would also like to thank the following people who have loaned their photographs and shared information for the publication of *Atherstone Through Time*: Brenda Adams Sale & Son Seed and Corn Warehouse and the Oust House 1972 (page 53), Roy Allitt, Dorothy Allitt, Alan Barnes, Bob Broadhurst, Gerry Barnes, Beryl and Charles Cooke, Horace Doherty, Owen Donovan, Sir William Dugdale, Vinnie Edwards, Geoff Freeman, Sarah Ford, Bill Ford, Vic Fenlon, Mr And Mrs Fletcher, Donna and Paul Gisbourne, Chris Green, Brian Gudger, Gordon Gudger, David Hickie, Chris Horton and Atherstone Cricket Club, Roger Howe and Paul Clamp at The Atherstone Heritage Motor Show, Walter and Margaret Horton, Brenda Holland, Derek Holt, Gary Jackson, Matilda May, Vic Prowse, Joyce Peart, Atherstone Rugby Club, Ann Randall, Dorothy Rushton, Mark Smallwood, John Spragg, John Stanley, and Mavis Turner.

Reproduced by kind permission of Warwickshire Library & Information Service: Coleshill Library. Photographs: 0133 Old Police Station. 0136 Town Hall. 0195 White Bear Inn. 0216 Ram Yard. Un-catalogued: Briggs, Long Street. Long Street (From Hill Top), Baxter & Sons. Long Street (From Church Street), Baxter & Sons. Market Place, Baxter & Sons. Grendon Hall, Atherstone, Baxter & Sons.

Reproduced by kind permission of Warwickshire County Record Office: photograph by Richard Margoschis PH1035/C9109 The Cotton Mill Yard c1950.

Reproduced by kind permission of :

Warwickshire County Record Office – PV Man Ath Chu 3.

Warwickshire County Record Office – PH 352/14/8.

Warwickshire County Record Office – Warwickshire Museum – C2997. Warwickshire County Record Office – Warwickshire Museum – C2489. Warwickshire County Record Office – PH (N) 882/181.

Warwickshire County Record Office – PH 352/14/68.

Warwickshire County Record Office –PH 352/14/1.

Warwickshire County Record Office – PH 352/14/63.

Warwickshire County Record Office – photograph by Frances Frith & Co. – PH 599/71.

Warwickshire County Record Office – PH 352/14/76.

Warwickshire County Record Office – PH 352/215/59.

Warwickshire County Record Office – PH 352/14/32.

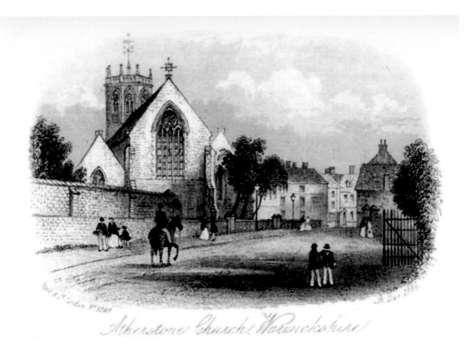

Atherstone Church, Warwickshire

St Mary's Church, South Side, 1830

This pencil drawing shows St Mary's Church in the early nineteenth century. It was completely rebuilt in 1849 except for the tower and chancel, which are the oldest parts of the present church. It is reputed that on 21 August 1485, the eve of the battle against Richard III that was to make him king, Henry Tudor took his last sacrament in the chancel. After the dissolution of the monasteries in 1538 the chancel was no longer used for worship. Instead, from 1573 until 1864 it served as the Queen Elizabeth Grammar School, granted by Queen Elizabeth I. In 1884 the chancel was restored and joined up to the newer nave. (W.C.R.O. PV, Man Ath Chu 3)

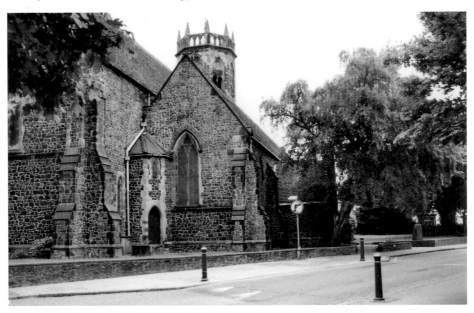

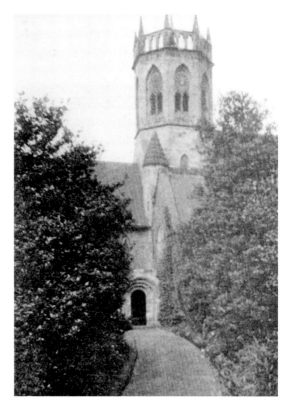

St Mary's Church, North Side, c. 1950
The rear view of St Mary's Church shows the twelfth-century Baddesley Porch, re-erected at St Mary's church when the 'old' Baddesley church was demolished in 1842. The Baddesley Porch was the private entrance from Atherstone Hall. The original ancient clock-face was on the north-east side of the octagonal tower, because up until 1799 the road went around the rear of the church to join Sheepy Road. A new, electric clock was added to the south side of the tower in 1960, donated by the late James Willis when he was churchwarden. The original clock was given to the Coventry Museum.

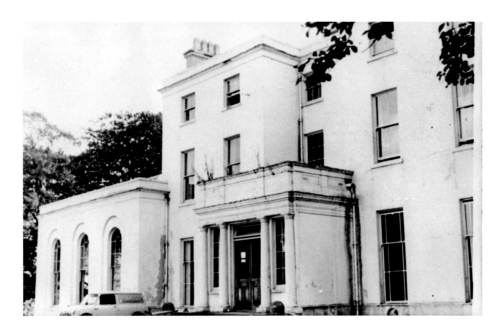

Atherstone Hall, 1963

Sir John Repington built Atherstone Hall in 1620 on the site of a thirteenth-century friary. 'Many curiosities have been disinterred near the old house. An amulet – highly perfumed, a cannon ball, musket balls and several pieces of silver money of the time of Elizabeth I.' (*Kelly's Directory of Warwickshire*, 1880.) Abraham Bracebridge purchased the hall in 1690. 'Abraham Bracebridge the 2nd was the grandson of the former owner by that name, and grandfather of that Abraham Bracebridge who died in 1832, leaving by his marriage to Mary Elizabeth Holte – daughter of Sir Charles Holte of Aston Hall, an only son – Charles Holte Bracebridge who had a reputation as a Shakespearian scholar, an antiquarian, and a philanthropist. Charles Holte Bracebridge died in July 1872. John Edward Compton-Bracebridge succeeded the property in 1908 on the death of his father – Rev. Berdmore Compton.' Atherstone Hall and grounds were sold in 1963 for a private housing development, namely Florence Close, Holte Road and Windmill Road.

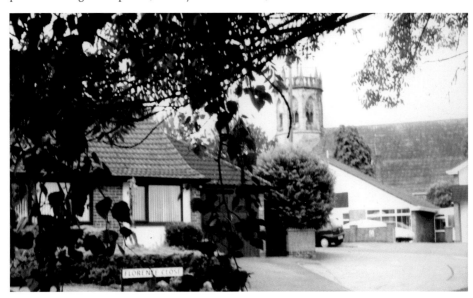

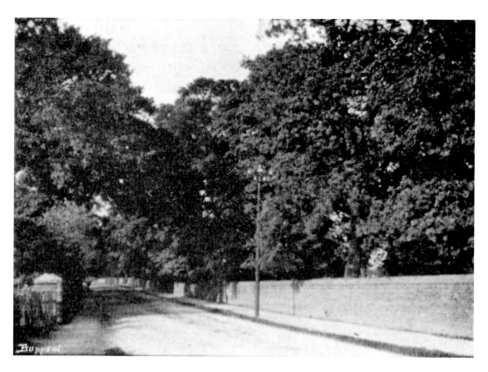

Sheepy Road, c. 1930
Atherstone Rural District Council built the new council house estate on the right-hand side of the picture in 1956. The housing estate became known locally as the 'Sheepy Estate'. Street names include St George's Road, Friary Road, Tudor Crescent, York Avenue and Royal Meadow Drive – it is believed Henry Tudor's army camped here before the Battle of Bosworth Field in 1485.

Sheepy Road, 1963

This photograph was taken just before the A5 bypass bridge was built in Sheepy Road. At that time, there were allotments behind the trees shown on the left of the picture. A street of houses was built on the site of the allotments, named Croft Road, along with the police station and magistrates' court, both of which have recently been put up for sale. The only allotment not destroyed by redevelopment in the 1960s, next to the cemetery, has recently been earmarked to become a nature reserve.

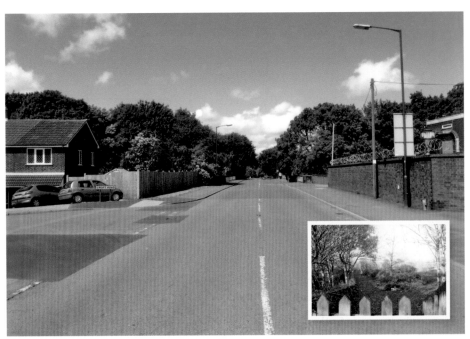

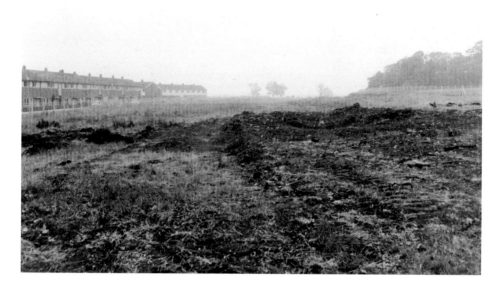

The A5 Bypass, 1963

In this photograph the A5 bypass is being constructed on pastures where children once played and took their picnics. There are many with fond childhood memories of the winter months of 1963/64, when one could go skating on the frozen-over bypass. Friary Road is on the left-hand side of the photograph, while Atherstone Hall and its grounds were situated behind the trees on the right. A surveillance map of Atherstone shows 'Bloody Bank' and 'St George's Knob' in the Atherstone Hall grounds, suggesting there may yet be more to unearth about Atherstone's part in the Wars of The Roses.

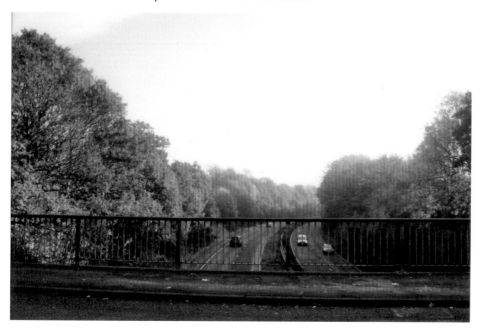

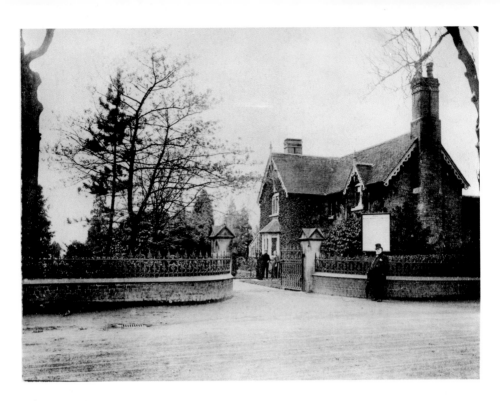

Atherstone Cemetery, *c.* 1900

Atherstone cemetery opened on the 26 April 1870. The Bracebridge family of Atherstone Hall gave the land to Atherstone Council for the purpose. Up until that time, Atherstone burials took place at Mancetter cemetery. Mr Slaney was the superintendent at the cemetery lodge and he is believed to be the man standing in the doorway in the photograph. The lodge was demolished and replaced by a bungalow in the 1960s. Jack Woodward was the superintendent for many years, until the bungalow was sold in the 1990s to a private buyer.

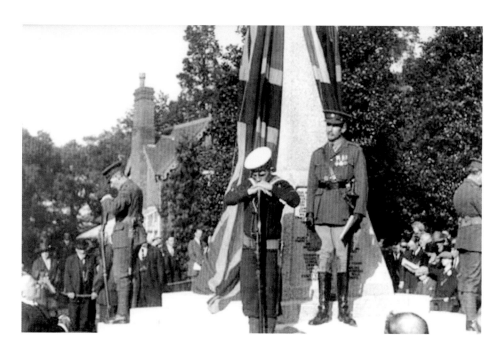

'Lest We Forget'

A very poignant and sombre two minutes' silence by servicemen at the war memorial obelisk in Atherstone Cemetery after the First World War. The unveiling ceremony of the war memorial obelisk took place on Sunday 30 September 1923. The modern photograph was taken on Sunday 13 November 2011 and shows the local community and dignitaries remembering those who gave their lives for us, and also those servicemen and women who are on active service in other parts of the world today. Joe Smith of the Atherstone section of the Royal British Legion takes a few moments to look at the poppy wreaths and crosses laid down by families and organisations in the town. (W.C.R.O. PH 352/14/1)

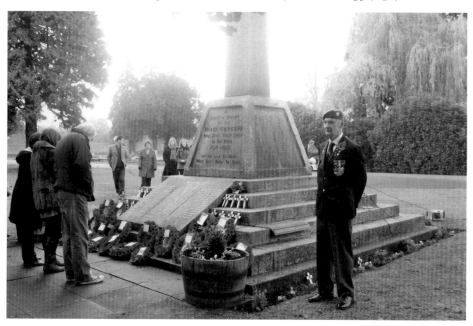

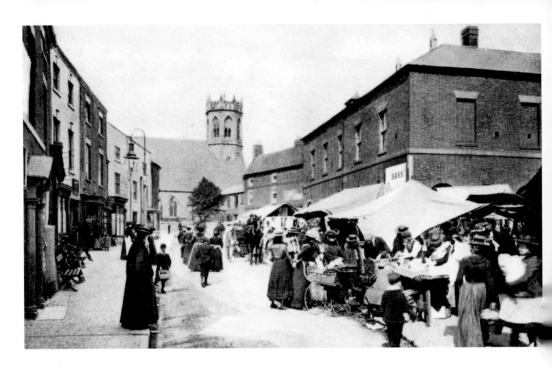

Church Street Market, c. 1880

This photograph of Atherstone market day in Victorian times shows the Market Town Hall in its former glory. It was demolished in 1963. The ladies' hats and dresses are to be admired, and the boys are well turned-out in breeches and ruffled collars under their smart jackets. Atherstone market continues to trade in the square on Tuesdays and Fridays.

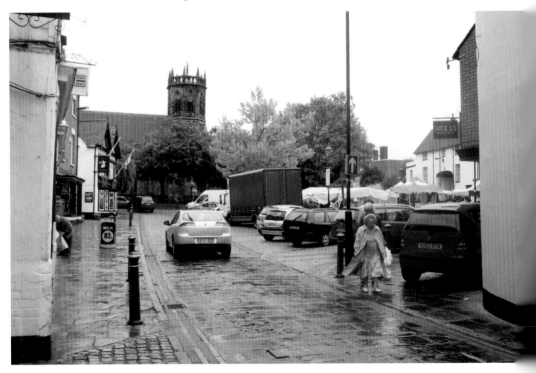

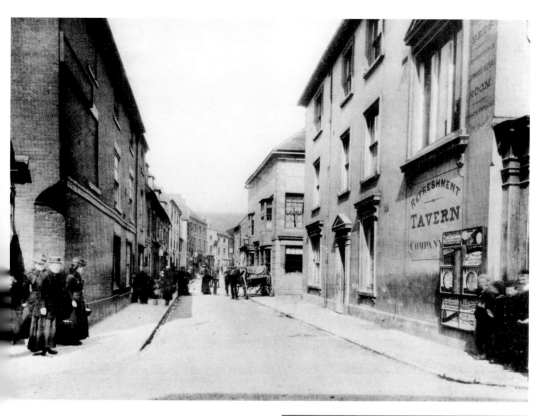

The Coffee Tavern, *c.* 1890

The Coffee Tavern opened in 1878 as a place for working men to meet socially away from the temptation of alcohol. The Coffee Tavern was also used to conduct important meetings. The entry, where I stood to take the modern photograph, leads to the 'back way' in Station Street. The library, childcare clinic, and the N.A.L.G.O. club were situated on the 'back way' before it was demolished to make way for a car park.

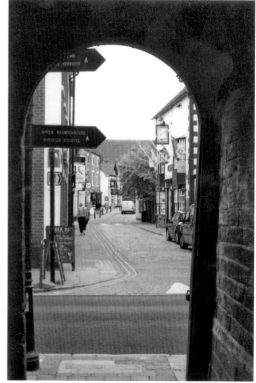

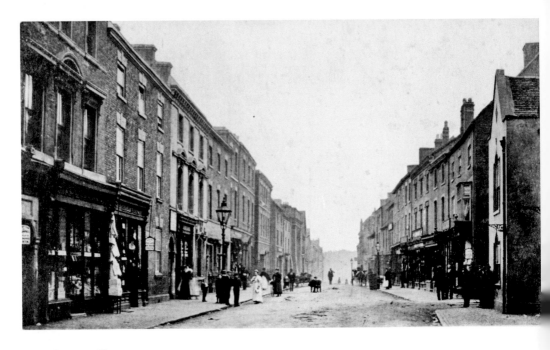

Long Street, 1880s

The centre of Long Street with the Red Lion Hotel on the right of the picture. Men, women and children are engaged in conversations. The street is complemented with gas lamps. The local lamplighter would light them before dark and put them out before dawn. The lamplighter had another chore to do each weekday morning: rousing the coalminers in time to start their shifts, by tapping on their bedroom windows!

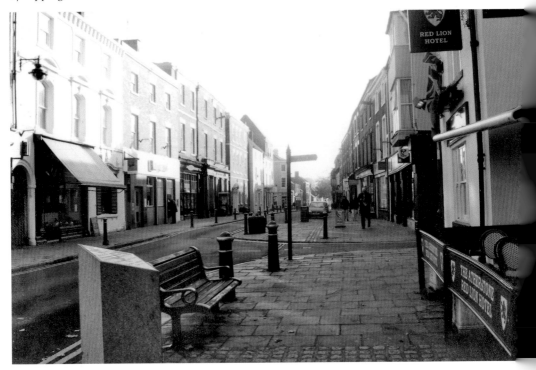

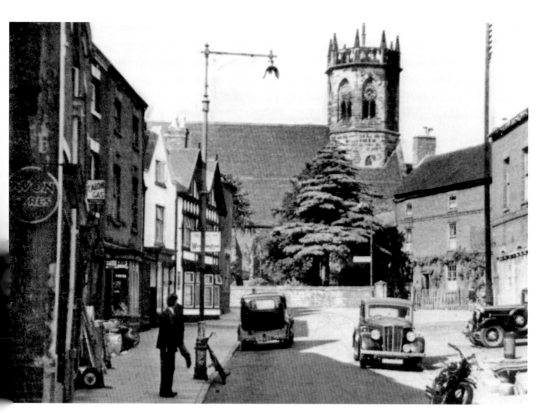

Church Street, 1940s
Church Street was formerly known as Bakehouse Lane. The cottages at the front of St Mary's Church were demolished in 1957. The vehicles in this photograph show that Church Street was for 'two way' traffic then. It has been a 'one way' street for a number of years now, as is Market Street, which runs parallel to it on the other side of the market square.

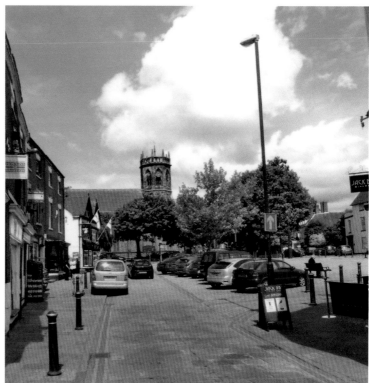

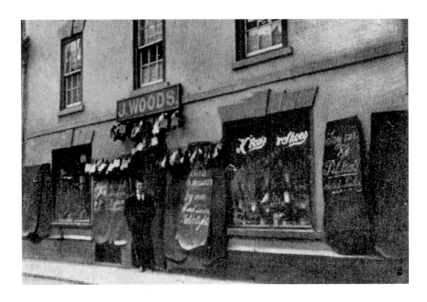

Joseph Woods' Shoe and Bootmaker's Shop, *c.* 1910

Number 10 Church Street was situated at the front entrance of Megginson's yard. In 1953 Mr and Mrs H. A. Woods, who ran the business, retired to Bournemouth. Mr Woods told the *Atherstone News* that his father, Mr Joseph Woods (believed to be the man in the in the photograph) took over the business from his grandfather, Mr W. Starmer, on 1 September 1883. Mr Starmer had himself succeeded his father, meaning that the shop had been in the family for at least five generations and over 100 years. In those days, hides were bought off the local farmers and they would be tanned on the premises. 'The boots for men – there were no shoes for men in those days – were all hand-sewn on the premises and the women's shoes were either laced or buttoned.' (*Atherstone News*, 20 March 1953.) Gerry Barnes continued the tradition, trading at 10 Church Street as a cobbler up until 2011. Today, the shop premises have been taken over by A* Laundry and Ironing Services with proprietor Adele Murray.

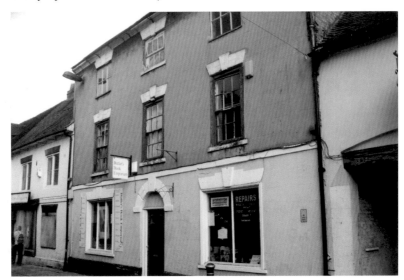

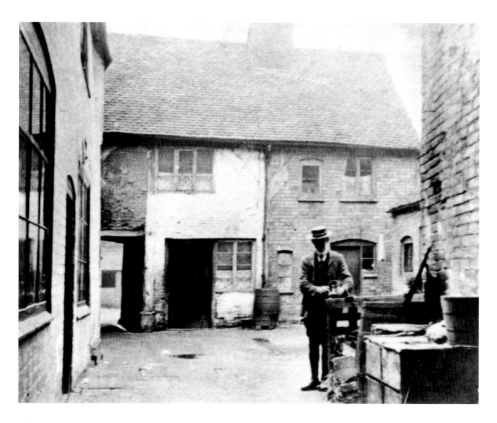

Phoenix Yard, c. 1900
The Phoenix Yard dwellings were built behind the Phoenix public house in Church Street. One of the original cottages still stands in the yard, adorned with hanging flower baskets and flower tubs. A new development of houses has recently been built alongside the cottage.

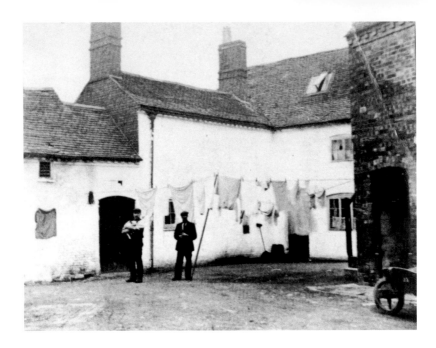

Angel Yard, *c.* 1900

The Angel Yard was at the rear of the Angel Inn. The Angel Inn is a free
house, and since 2002 has been under the ownership of Lynda and Darren
'Snowy' Snow. A beer garden now takes the place of the Angel Yard where
people once lived. Beer festivals, national events and anniversaries are
celebrated, and fundraising events take place for various charities throughout
the year. The interior of the Angel Inn authentically captures the feel of a
traditional old English pub, with its low beams and a woodburner surrounded
by an inglenook fireplace. The Angel Inn was the traditional 'home' of the
Atherstone Ball Game for many years. The Ball Game committee and stewards
all met here before the game kicked off at 3 p.m.

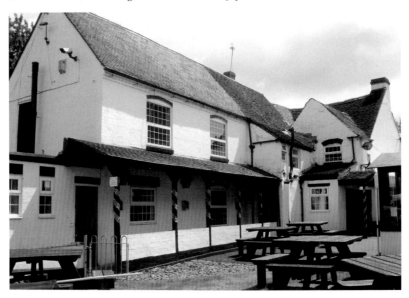

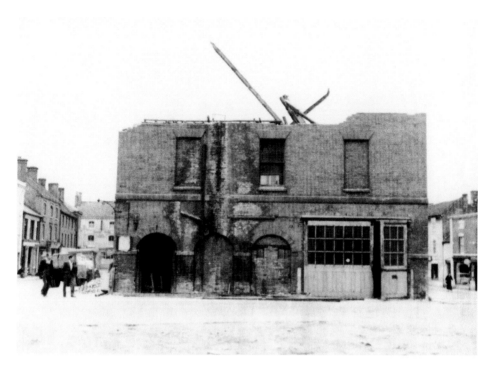

Market Town Hall, 1963

The Market Town Hall was built in 1854 and demolished in August 1963. The double doors of the fire station, where the fire engine was kept, can be seen here underneath the Town Hall. At one time there were market stalls inside the Town Hall as well as outside. The hall hosted a variety of events upstairs, including dances, boxing contests, pantomimes and puppet shows. More prosaically, during the 1940s it was used as the dinner hall for pupils of the Infants School. (1963 photograph 0136)

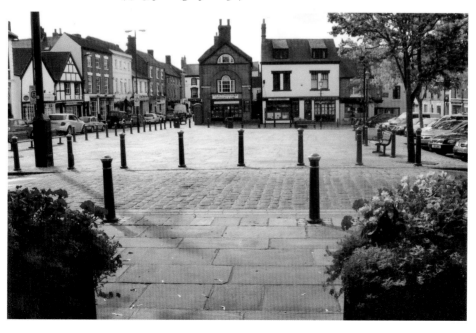

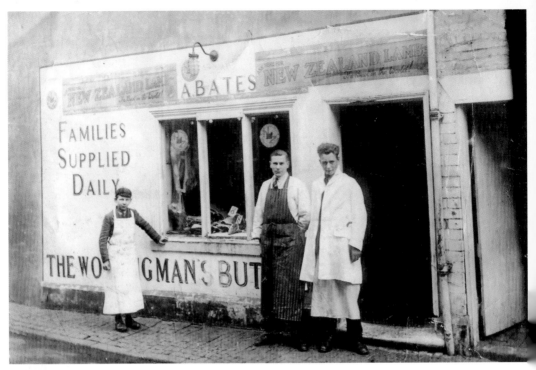

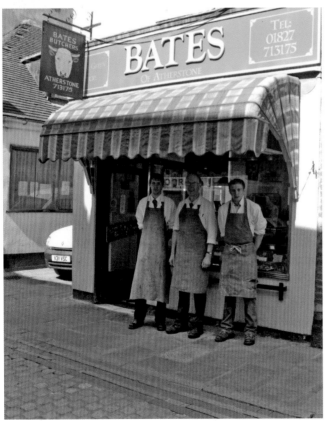

Bates' Butcher's, 1930 – 'The Workingman's Butcher'
Bates' Butcher's originally traded at 5 Church Street (now the wine bar). Left to right in the upper picture are young Wilfred Bates, Fred Chadaway and an unknown person. In 1918, no. 6 Market Street was a shop owned by Mrs W. Cadman, selling 'poultry, game and rabbits (all English)'. The shop also advertised the sale of 'all the finest fish from Grimsby fresh daily'. Nowadays Bates' Butcher's trades at 6 Market Street and has done so since 1945. Left to right in the lower picture are Ashley Haynes, Chris Green and Mathew Gothard.

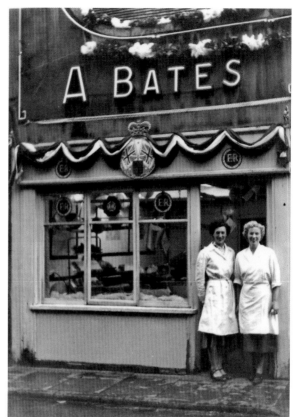

Bates' Cooked Meats, 1953
No. 4 Market Street was Bates' shop too, selling sliced cooked meats such as ham and pork. Standing outside are Mary Bates and Peggy Bates. This photograph was taken in 1953, when the shop was decorated to celebrate the coronation of Queen Elizabeth II. The premises have changed use over a number of years. Most recently it was a denture-repair shop. However, these days it is boarded up, with no trading at all at the premises.

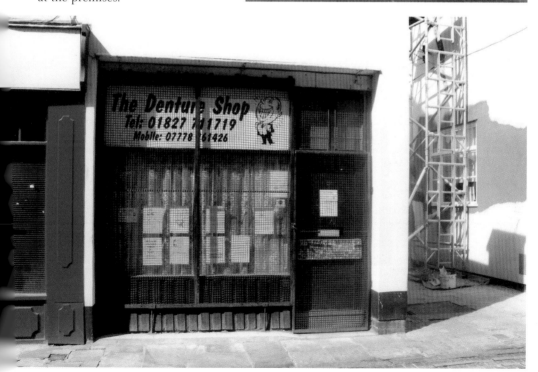

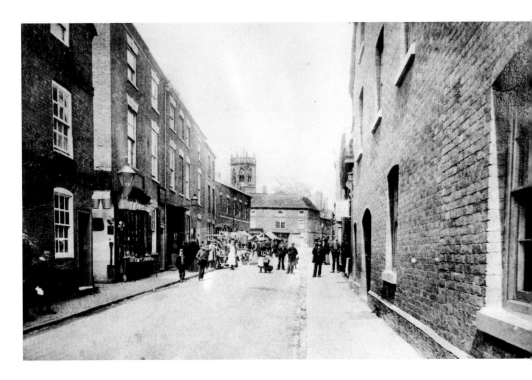

Market Street, *c.* 1900

Little has changed in Market Street, formerly known as Butchers Row, over the years, apart from businesses appearing and disappearing over time. Hiscock's department store, Smith's card shop, the *Atherstone News*, Gale's sweet shop and Saddlers, a small café – complete with a jukebox – were among the businesses located here in the 1960s and '70s. On the corner of Market Street and Long Street, people stopping to greet friends while out shopping are still a familiar site.

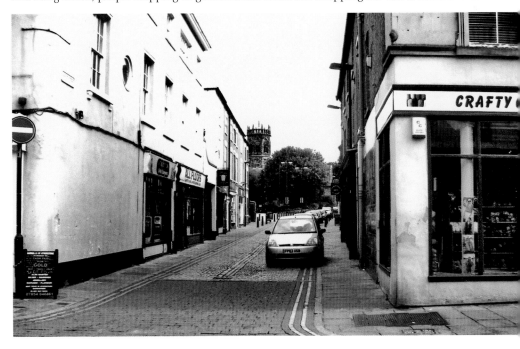

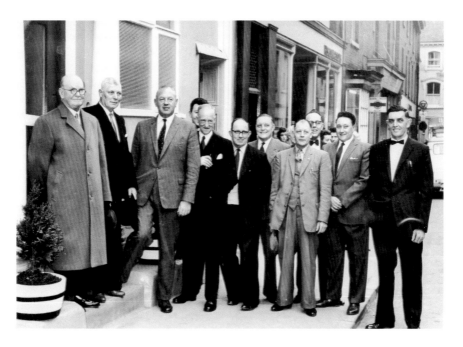

The British Ex-Servicemen's Club (The Legion), *c.* **1950**

It was a proud moment for everyone involved when The British Ex-Servicemen's Club building was extended around 1950. Left to right: Herbert Swift (Treasurer), George Cheshire (Chairman), man from the brewery, Gerald Austin, Frank Gudger, Joe Dingley, Bill Morris, Bill Spooner, Roy Roberts (Vice-chairman) and Rene Lee (Secretary). Members of the Atherstone Royal British Legion changed their venue around twenty years ago and now meet every month at The Conservative Club in Long Street. Their longest-serving member is ninety-year-old Dora Warner, who was the president of the Women's Section until it merged with the Men's Section. All of the members are dedicated to fundraising throughout the year for the British Legion Poppy Appeal.

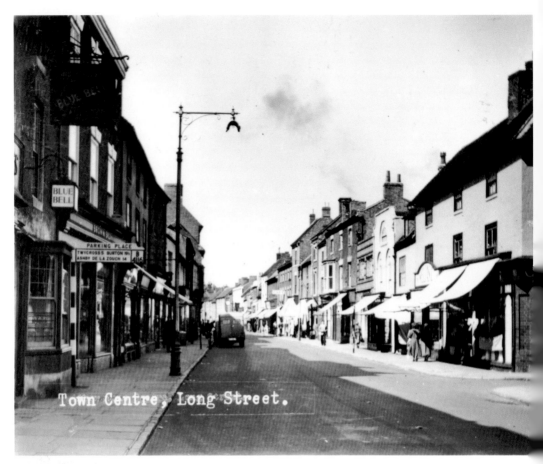

Town Centre, Long Street.

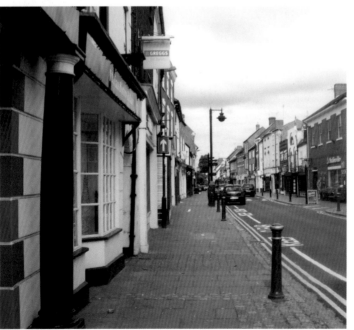

Long Street, 1950s
The Blue Bell Inn sign is apparent on the left of the picture. For many years it was here, at 87 Long Street, that the Shrove Tuesday Ball was thrown out from the balcony. A celebrity, having appeared in the Christmas Pantomime at Coventry Theatre, would have had the honour of throwing the ball out to the excited awaiting crowd. The Blue Bell Inn was altered and up until recently a shop called Aladdin's Cave, selling household goods, traded there.

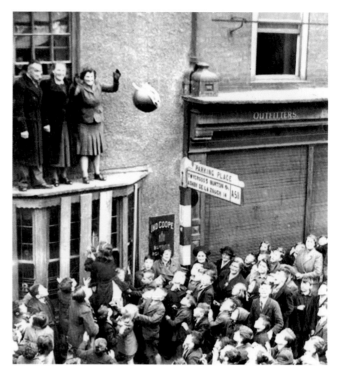

Eve Boswell Throws Out the Shrove Tuesday Ball, 1930s
Eve Boswell was an Australian 'Zither' player (a flat musical instrument similar to the harp). The window ledge at the Blue Bell Inn was the 'stage' for Atherstone on Shrove Tuesday for many years. The crowds were excited to see the celebrity and the children are eagerly holding their hands out high, catching fruit, sweets, and showers of pennies. It is a tradition that continues today. In 1997, long-serving organiser and committee member Graham (Rocky) King had the honour of throwing the ball out from the upstairs window of Barclays Bank in Long Street.

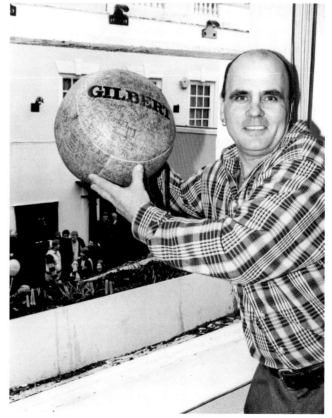

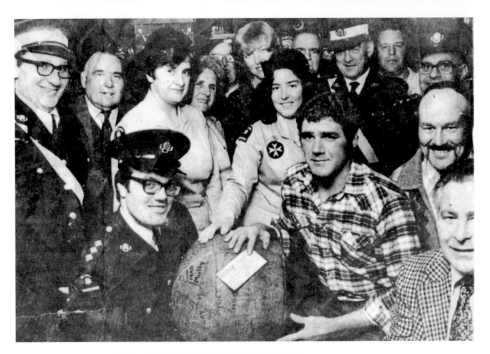

Ball Game Winners – Gary Jackson, 1980, and Tom Jackson, 2011

Gary Jackson has won the Ball six times over the years. It is customary for the winner of the Ball Game to take the winning Ball around the pubs in the town, to raise money for local causes. The Atherstone St John Ambulance Brigade members looked delighted when Gary presented Aubrey Screaton with the £309 that he had collected for their cause. Tom Jackson (Gary Jackson's son) was seventeen years of age when he first won the Shrove Tuesday Ball in 2004 and was the youngest ever, recorded winner. In 2011, at the age of twenty-four, Tom was destined to win the Ball again.

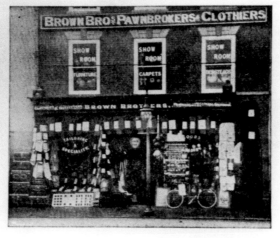

Pawnbrokers,

Clothiers,

Outfitters.

Carpets.

Jewellers,

and

House

Furnishers.

Bedsteads.

FROM **BROWN BROS.,**

ATHERSTONE. 191

Brown Brothers, *c.* 1920

Brown Brothers placed an advert in the *Atherstone News* on Friday 3 January 1896 promoting themselves as 'The Cheap Clothiers', selling men's double-breasted overcoats at 21s, youths' overcoats at 10s 6d – boys' cape overcoats 8s 11d and boys' reefers at 3s 6d. The entry next to the shop leads to the 'back way' (Station Street). In the entry there was a side door to Brown Brothers, where the pawnbroker traded with his customers discreetly. People often pawned items when they had no money for food or rent. Pennies Worth trades there today, selling a variety of goods, including card making and craft items, catering goods, and gardening and DIY essentials.

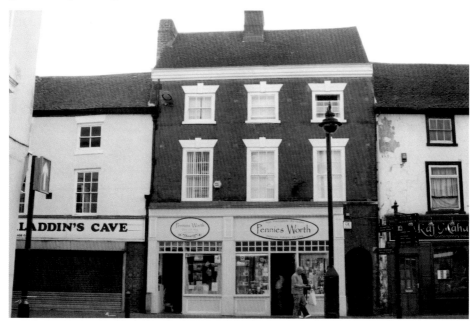

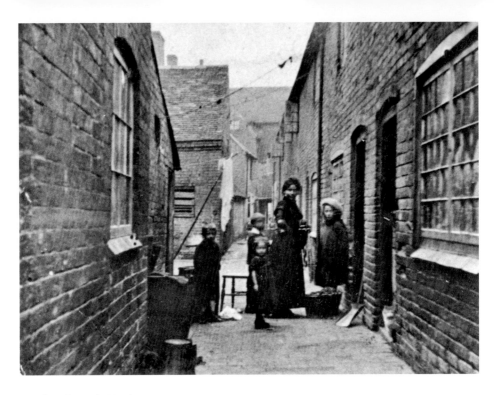

Hand and Bottle Yard, *c.* 1900
Hand and Bottle Yard was behind the Hand and Bottle pub, which is now the Atherstone Gallery shop, owned by Sue and Geoff Smalley and specialising in fine art and picture framing. Geoff's grandfather was born in Hand and Bottle Yard in 1895. Geoff and Sue's daughter, Laura, was born in the living accommodation above the shop in 1982.

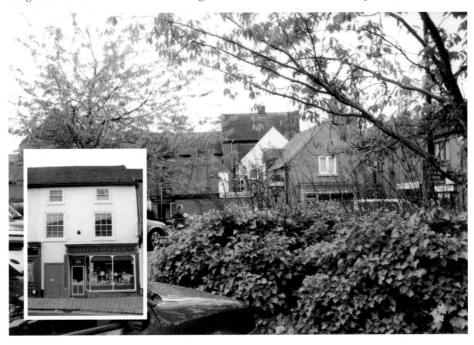

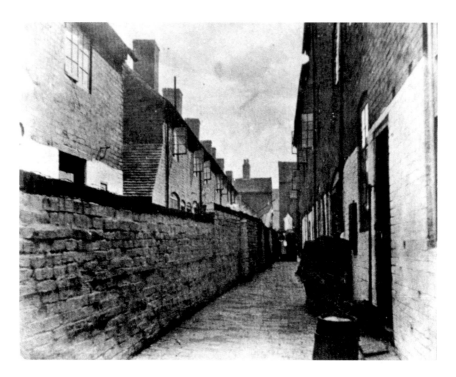

Druids Arms Yard, *c.* 1900

Druids Arms Yard was behind Stringer's fishmonger's and greengrocer's shop in Long Street. In the 1970s John Day bought the business, and on his retirement in 2002 the shop was sold to Paul and Dawn Jephcote. Paul has remounted the sign of the Druids Arms Yard above the original yard entrance on Long Street. The shop is now called Hours For Flowers and has expanded greatly over the years, stocking every type of flower and plant imaginable, with an aroma of delightful fragrances as you walk in and around the shop. Paul Jephcote is in the picture, watering plants at the rear of the shop, where families once lived in their tiny old dwelling houses.

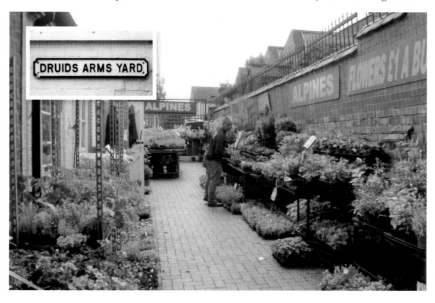

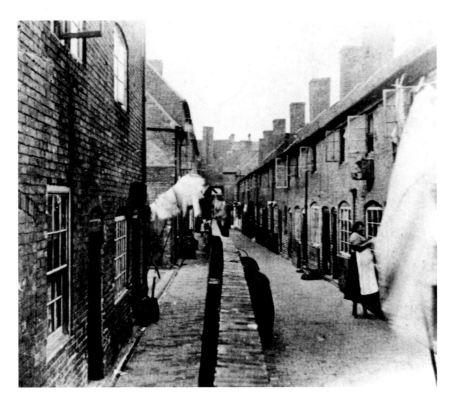

Spencers Yard, *c.* 1930

Spencers Yard was the yard behind Tunbridge's butcher's shop and abattoir at 63 Long Street. Tunbridge & Son had traded at 63 Long Street since 1875. The outbuildings on the left of the picture in Spencers Yard still remain there to this day, although they are now in a dilapidated condition. Pav Congrave has had his confectionery and off-licence business at 63 Long Street since 2006.

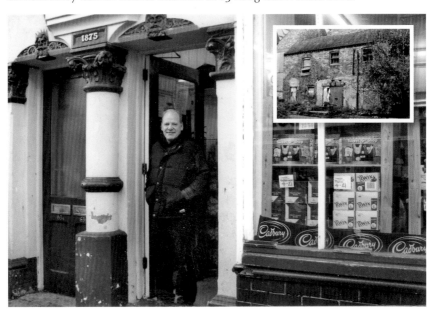

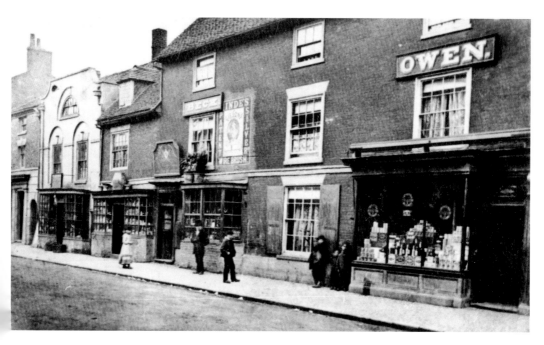

Long Street, *c.* **1880**

A quieter day in the town – it could be a Thursday when it used to be Atherstone's half-day closing. Shop doors are closed and three small children stand shyly at the side of John Owen's grocer's and druggist's shop and Thomas Beck's saddler's & harness-maker's shop, while others wait for the photographer to take the picture. In the 1960s, Pickering's toy and music shop traded at no. 74, with Pickering's jeweller's next door at no. 76. Café Revive, Lewis Pointon estate agents, The Olde Sweet Shoppe and Nationwide are the businesses that trade in these premises today.

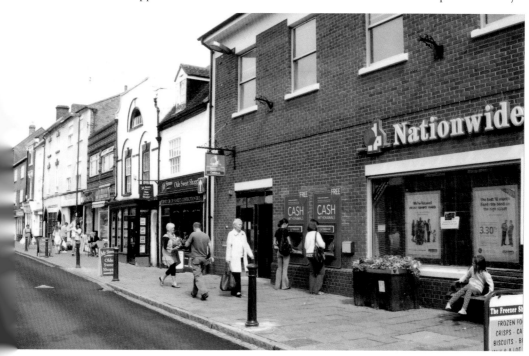

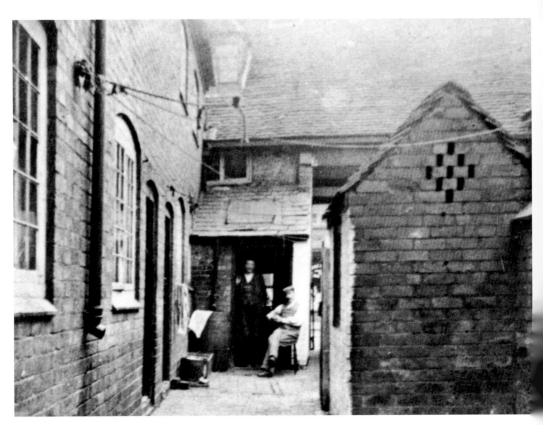

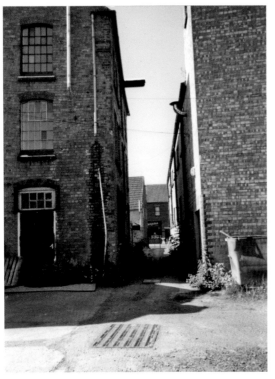

Brown Bear Yard, *c.* 1910
The Brown Bear Yard was situated behind the Brown Bear public house. In 1880 Edward Peckover was the landlord. In later years the premises served the community as a newsagent's shop known as Green's, and later Gale's. These days the newsagent's premises, in Long Street, are boarded up. The sign for the Brown Bear Yard was mounted on the brick wall at the side of the newsagent's when Mr Gale owned the shop. Hatton's hat factory buildings, which were behind the Brown Bear Yard, can be seen today in a dilapidated condition.

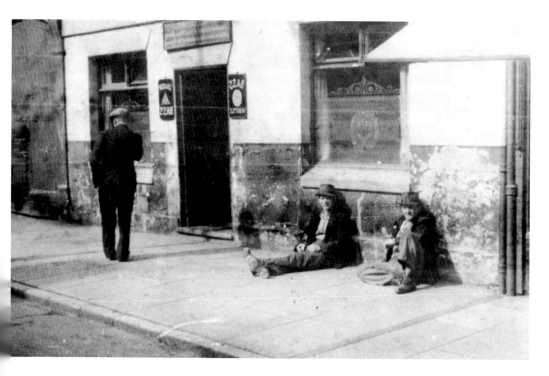

George and Dragon, *c.* 1930

The George and Dragon pubic house was one of many public houses in the town that have been altered or demolished in the last half-century. The George and Dragon building is now a jeweller's shop called Gold & Silver Investments.

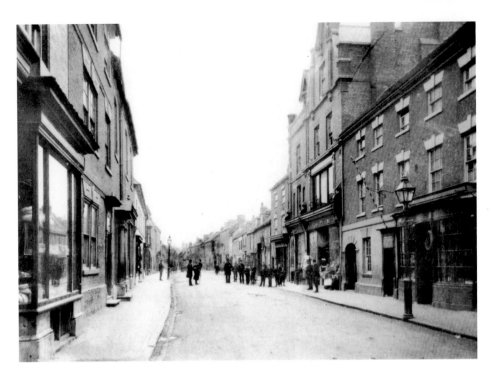

Long Street, c. 1900

Looking down towards the station end of Long Street, an array of shops selling their wares can be seen. On the left is a baker's shop with freshly made bread on display. Over the years some of these shops have disappeared from Long Street. Woolworths was built on the site of one of the demolished building in 1936. It was run as a variety store with everything under 6d. Woolworths was one of the first stores where people could look and choose for themselves before purchasing items. The store closed on 6 April 1989. In recent years, Atherstone Carpets took over the premises and are still trading there today.

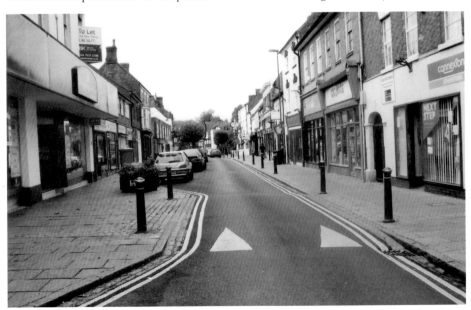

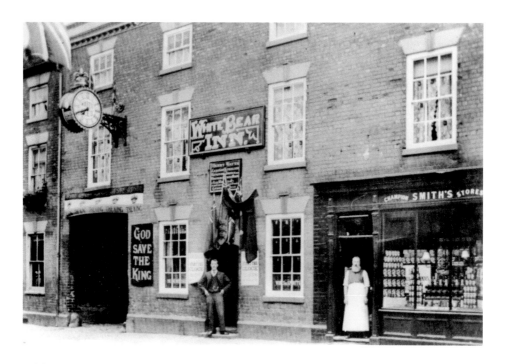

White Bear Inn, 1902, and Ram Yard Entrance

It is believed that the man in the picture is Henry Watt, who was landlord of the White Bear Inn. The clock was donated to the town to commemorate the coronation of Edward VII in 1901. Over the years the White Bear has come to be known locally as 'The Clock'. The licensees, Shaun Greening and partner Debra Hall, took over the White Bear in 2006. Every Thursday, Shaun winds up the clock by hand. The workings for the clock, in a cupboard upstairs, are huge, and are wound up using a type of cranking handle. The inset picture is of barmaid Sarah McGuffog and landlady Debra Hall in 2011.

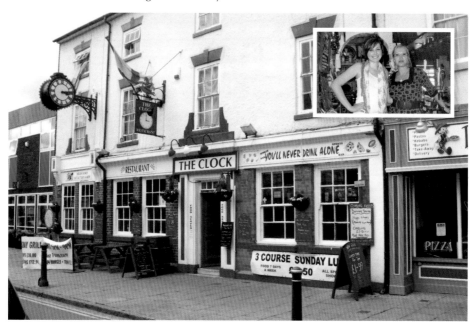

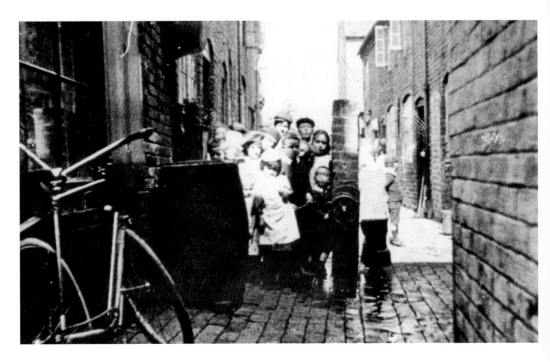

Ram Yard, c. 1920

The Ram public house was owned by Mrs Elizabeth Hatton in 1880 and was adjacent to the White Bear Inn in Long Street. The picture shows Ram Yard, where people once lived and children played in a close-knit community. One lady said that the children would go snowballing in Long Street with some of the pitmen. Atherstone library now stands on the site of the Ram public house. (1920 photograph 0216)

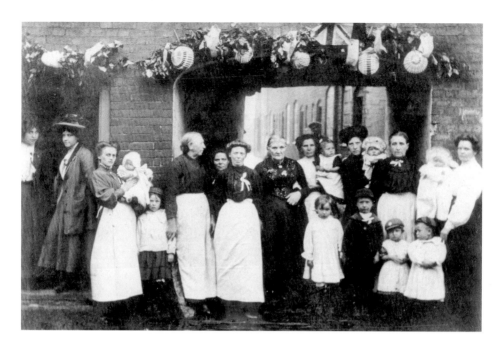

Garden Row, c. 1910

The Garden Row entrance, decorated for the Atherstone Carnival. Mrs Eaton is standing in the centre of the picture with other members of the Eaton family and neighbours. Garden Row and Cloebury's Buildings were two of the yards that were inhabited and had stood where the Memorial Hall and swimming baths are situated today. 'Garden Row had four outside toilets halfway up the yard, a washhouse, a water boiler and an outside water pump. There were four more outside toilets at the end of the yard.' says Gordon Gudger, who used to live in Garden Row, while Barry Stone, who lived in Cloebury's Yard as a small boy, recalls: 'Cloebury's Yard had two outside toilets, a water pump and a washhouse. Mothers had to take their turn in what days they could light the boiler in the yard and do their washing in the washhouse.'

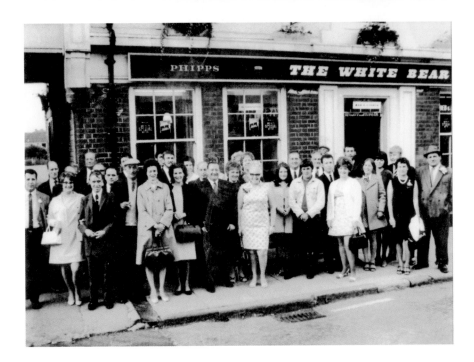

White Bear Inn Darts and Dominoes Team, 1971

The 1971 Darts and Dominoes team take a day trip to a venue called 'The Sea Around Us' at Lutterworth. Some of the named people in the photograph are: Ron and Ada Russell, Mick and Val Barber, Sheila and Keith Styles, Jackie Brindley, Nona, Dave Kent, Pete Swift, Dave Smith and his wife, Brian Orton and his wife, Reg and Eadie Graining and Bill Cotterill. The Clock F.C. 2011 is pictured below: Back Row: Jordon Coles, Shaun Greening, Tom Hall, Mark Healey, Martin Wilson. Front Row: Dave Coles, Paul Gilbert, John Stanley, Dave Brown, Nick Bailey, Gary Stacey, Jim Carroll, Scott Mullett, John Parkes, Nathan Billington, Ellis Merry, Mitchell Benson, Andy McAllister.

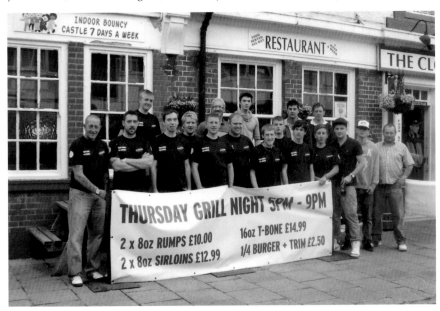

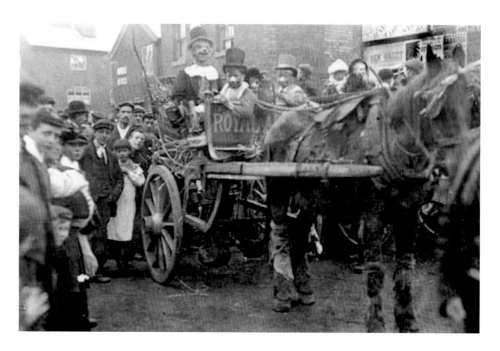

The Ally Sloper's Turnout on Carnival Day, 1905

Ally Sloper was, according to M. J. Alexander and J. L. Slater, 1992, 'a popular cartoon character of the period and was noted for apeing the aristocracy'. It seems that Ally Sloper is the boy wearing the top hat. The Baddesley Mother and Toddler Group are captured in this 2011 photograph, having a taste of life in the Wild West for a day. (W.C.R.O. PH 352/14/76)

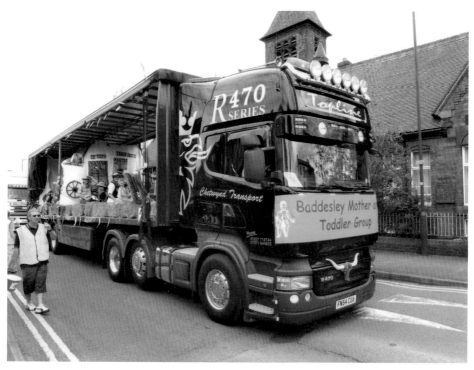

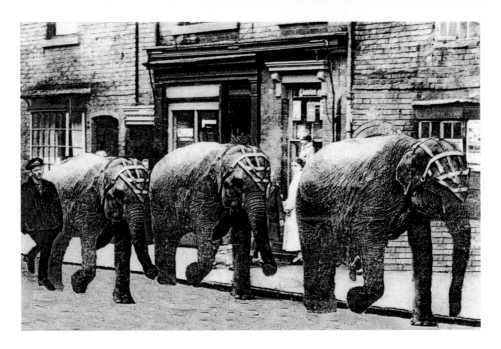

The Circus Comes to Atherstone, 1953

It was the coronation year of Queen Elizabeth II. The picture was taken outside Mr and Mrs Wykes' grocery shop at 10 Long Street. Jane Wykes, Freda Wykes and Elizabeth are shown in the picture watching the procession. The elephants and their trainer had just arrived at Atherstone train station. They got off the train at the sidings (positioned before the passenger platform) where goods were loaded and unloaded. No. 10 Long Street is now called New Images hair and beauty salon. Jane Wykes owned the salon for many years before it became New Images.

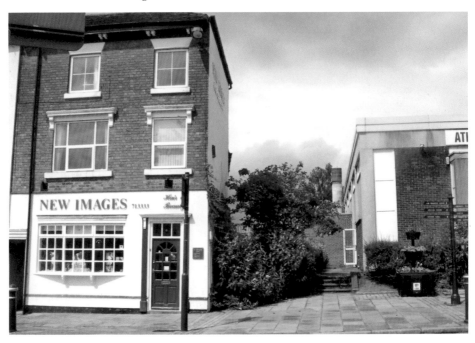

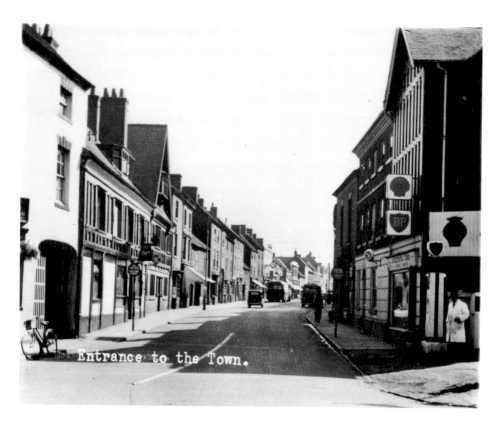

Entrance to the Town.

Rogerson's Garage, 1950s

Rogerson's garage and petrol station was situated opposite the White Hart Inn on Long Street and built in front of Melbourne House. After the clearance of some of the yards at this end of Long Street and the demolition of the garage and Melbourne House, a new Shell garage was built on the site in the 1960s. It too was demolished some years later.

ROGERSONS GARAGE
★
REPAIRS and OVERHAULS
PETROL and OILS
BREAKDOWN EQUIPMENT
★
Long Street and Station Street
ATHERSTONE
PHONE : ATHERSTONE 2144

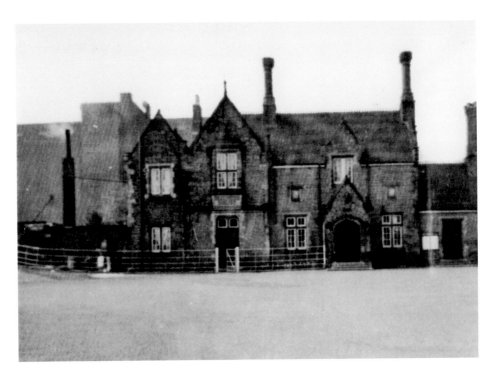

Atherstone Train Station, *c.* 1960

Atherstone train station and Station House can be seen here showing the Silo grain mill in the background. The Silo grain mill has since been demolished. The train station buildings, built in 1847, were saved from demolition in the 1980s. Eric Fox was the Stationmaster during the 1950s and '60s and lived at Station House with his wife and family. The railway bridge to get to the opposite side of the train line is in need of repair and is sealed off. Passengers do however have access to a new pathway where the 'wicket gate' used to be.

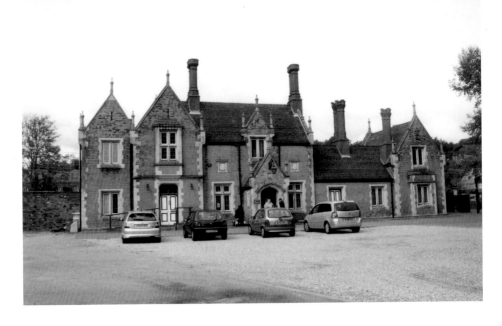

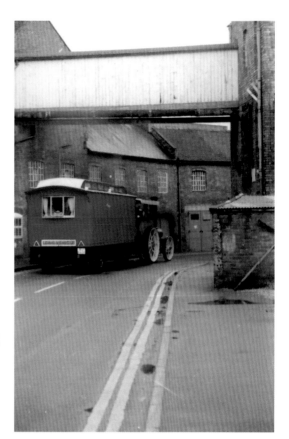

Vero & Everitt's Hat Factory, 1985
The Victorian hat factory stood in Station Street, and was once described as 'something out of a Charles Dickens novel'. Generations of hatters had worked here, following in the footsteps of their parents and grandparents. The factory doors closed for the last time on 4 December 1987. Work was transferred to the last remaining felt-making hat factory at that time, Wilson & Stafford's, situated on the canalside at Coleshill Road. By the 1990s Wilson & Stafford's had also closed down. The site of Vero & Everitt's hat factory was demolished to make way for a new Co-op superstore and petrol station. Alan Tingay is seen here early one morning, driving his traction engine, which he used for pulling the boats in on the canal. The boatyard was at the canalside, near the Outwoods.

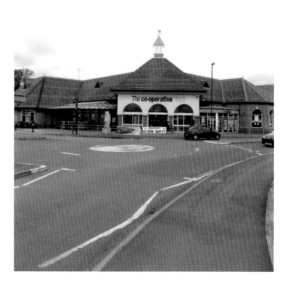

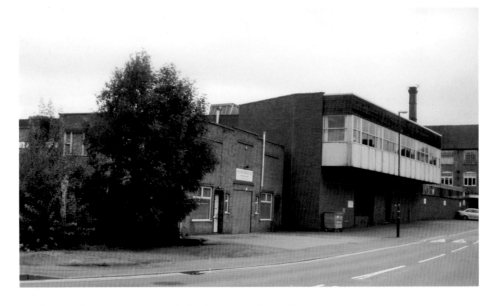

Denham Knitwear Factory and the Coventry Brace Factory, 2004

The Denham knitwear factory (right) was built in the 1950s on the site of Bingham's Row and The Swan With Two Nicks Yard. Hinckley Knitting took over in the 1970s. The Coventry Brace factory employed outworkers as well as factory workers when business was booming in the 1960s and '70s. Both buildings were demolished in 2005 to make way for the new Aldi store. The office block of the Hinckley Knitting factory still stands, and is currently used by various businesses including J. K. S. Training Station, situated on the ground floor.

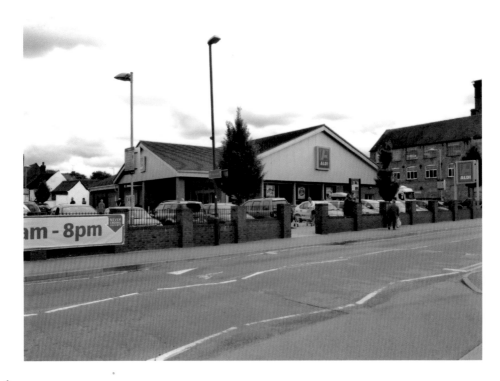

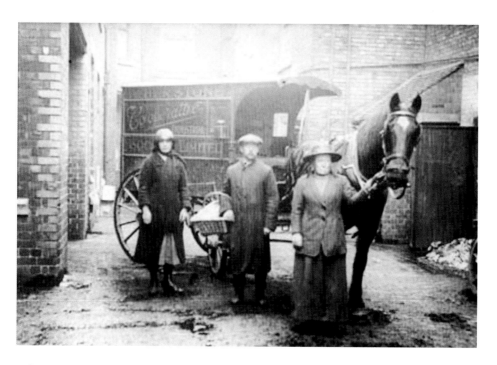

Atherstone Co-operative Society, 1900s

The delivery horse and cart are loaded up ready to deliver groceries in the neighbourhood. This may have included the surrounding villages that stand just a mile or two away from the town centre. The Co-op still remains in Long Street, Atherstone. The back entrance is apparent in the 2011 photograph. Opposite the back entrance is where the Cattle Market used to be, now a car park. (W.C.R.O. PH 352/14/8)

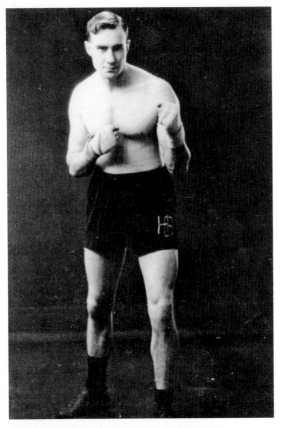

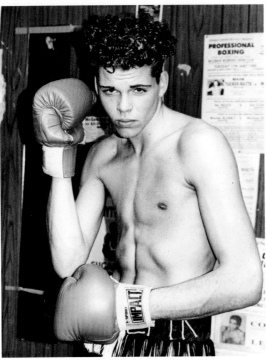

Boxers Harry Barnes, 1933, and Mark Smallwood, 1992

Atherstone-born welterweight boxing champion Harry Barnes rarely lost a fight. He organised matches at local outdoor events such as Atherstone Carnival, where he would be the referee, and at Atherstone Town Hall, in which all the best-known midlands boxers fought; they were always a 'sell out'. He went on to form Atherstone Boxing Club in the 1950s. Mark Smallwood, pictured here in 1992, has lived in Coleshill Road for most of his life. Mark turned professional at the age of seventeen years and went on to win nineteen professional fights out of twenty-one. In 1998 he fought Clinton Woods (who later became world champion) for the British light-heavyweight title. Barry McGuigan pronounced him 'one of the brightest British boxing prospects he had seen over the last ten years'. Now, at the age of thirty-six years, Mark has been commissioned by the Midlands Boxing Board to obtain his 'Corner Man & Pro Trainer' qualifications. Besides training youngsters at the J.K.S. training centre, he puts his energy into the boxing career of his fourteen-year-old son, Dre Smallwood.

The White Lion Yard *c.* 1920
The White Lion Yard was situated in Station Street, behind the White Lion pub, known locally as 'Sweeties'. The tall chimney is still prominent today. It is thought that the chimney may have been built on to a bakehouse. Some of the brickwork inside of the pub where it has been extended shows the outline of a fireplace that was once part of an old dwelling house in the Yard. The Yard area now serves as a beer garden and is a very popular place to enjoy a meal.

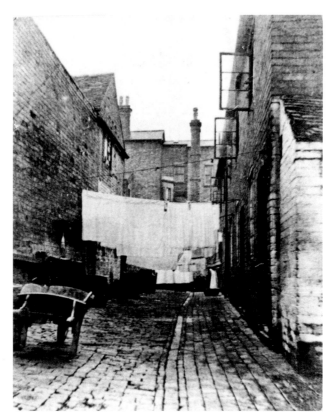

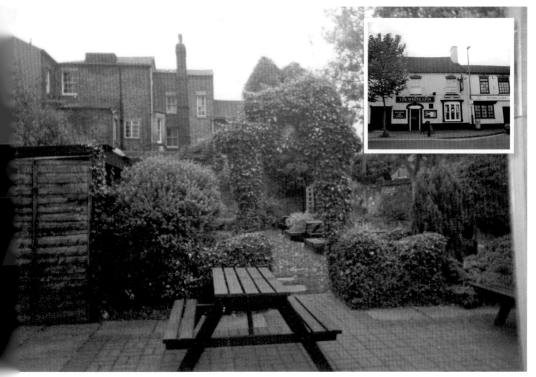

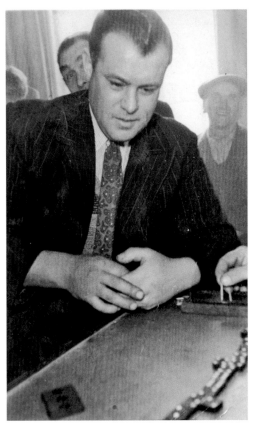

Jim Foster, 1960
Atherstone Monday Night Darts & Dominoes League at the Bulls Head. Every pub in the town had its own Darts & Dominoes team, and competition was taken seriously. After a competitive evening there would be a hot supper laid on for everyone. Someone once said that when the away team turned up to play dominoes at the Bulls Head, they were made to sit on the seats with the mirror behind them in the bar, so that the home team may take a sneaky look at what dominoes they had chosen! The Bulls Head building is on the corner of South Street and Coleshill Road.

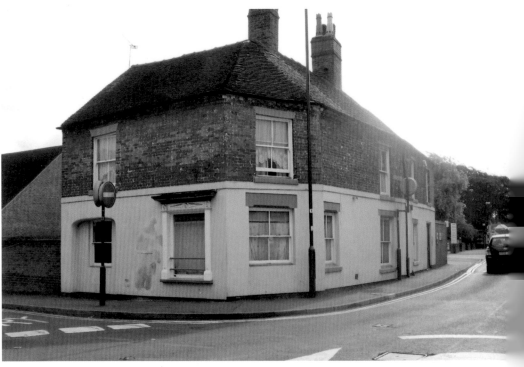

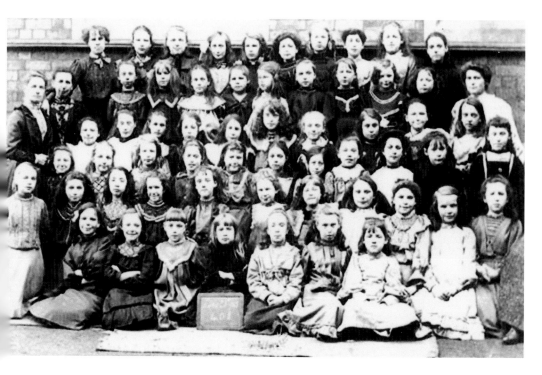

Atherstone School Girls, 1905

This group of young girl pupils posed with their teachers for the photograph to be taken on 31 December 1905. The photograph suggests that they probably attended the Atherstone Girls School that was built in Owen Street in 1893. The school was later known as South Street Junior School and catered for boys and girls. These days the school is Owen Street Community Arts Centre. (W.C.R.O. PH, 352/14/32)

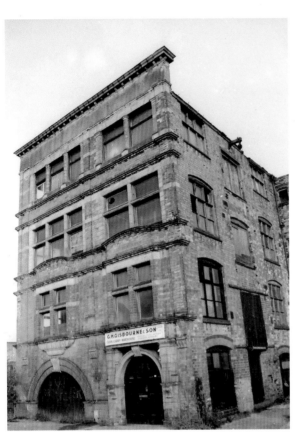

Gisbourne & Son Seed and Corn Merchants, *c.* 1992

From their seed and corn warehouse in Owen Street, G. H. Gisbourne & Son supplied local farmers with seed and corn. George Gisbourne took over the business from his father, George Henry Gisbourne, in 1923 and later ran it with his own son, Keith. During the Second World War, the Ministry Of Defence took over three floors of the warehouse to store food products., Keith Gisbourne bought George Mason's pet shop in Hall Lane on Coleshill Road in 1971, and it became a pet, garden and hardware store. In 1998 Keith passed away. His long-standing customers knew him as helpful, friendly, and a true gentleman. Donna and Paul Gisbourne now run the business. Donna recalls the day in 1992 that the warehouse had been burned down. "It was a shock ... There were many family history and business artefacts in the warehouse, which sadly, can never be replaced."

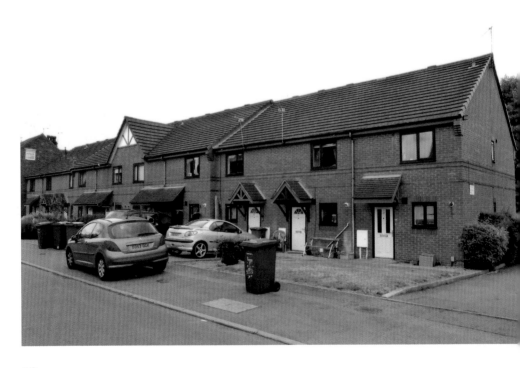

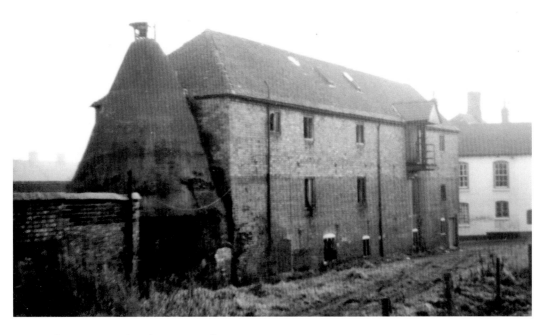

Sale & Son Seed and Corn Merchants, 1972
Sale & Son seed and corn merchants had traded in South Street for many years. The Oust House can also be seen in the picture. The rooftops and chimneys of two small houses can be seen on the left of the picture. These were demolished to make way for the new road, Woolpack Way.

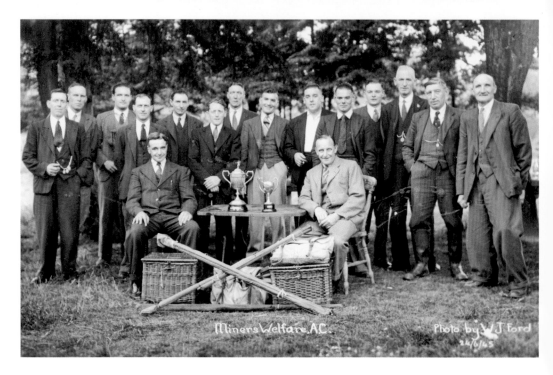

The Miners' Welfare Angling Club, 1945
The Miners' Welfare Angling Club had an enormous display of silver trophies, cups and shields to be proud of inside the club. The Angling Club had accumulated them over many years. The Miners' Welfare is nostalgically remembered for the discos held there every week in the 1970s and '80s – especially by the forty to fifty-year-olds! Housing developments took place in South Street when the Miners' Welfare Club was demolished after the closure of Baddesley Colliery in the late 1980s.

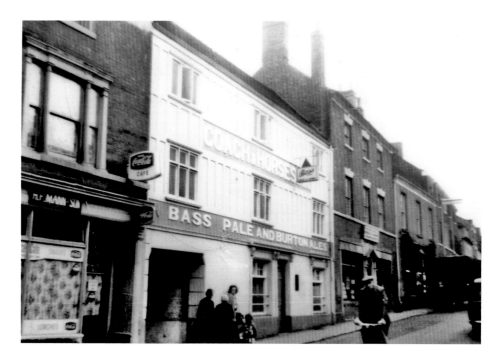

The Coach & Horses Inn, 1964

Harry Barnes, the boxer, lived at the Coach & Horses Inn with his mum and dad in the 1930s, before moving to the Blue Bell Inn. Lil and Ted Emery were landlady and landlord of the Coach & Horses for over twenty-five years before it was closed down for demolition in the 1970s. Next door on the left of the picture is Mann's café which was popular for bacon and tomato batches, sausage and onion batches, and pork and stuffing batches. It was a choice of either fish and chips from the local chip shop or a batch from Mann's café when people fancied a take-away.

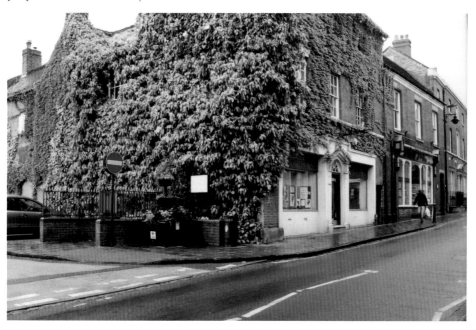

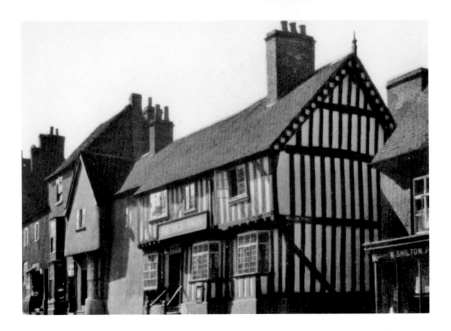

The Old Swan Inn, *c.* 1930

The Old Swan Inn is a listed sixteenth-century inn situated at the 'top' end of Long Street. In April 1785 the White Swan Inn was advertised in the Coventry Mercury as being 'almost wholly new with stabling for fifty horses'. An American survey was carried out at The Old Swan in 2008. They found evidence to suggest that the original building was a domed edifice, dating back to the fourteenth century. They found the upstairs floor to be made of stone. This oldest part of the building – being that part on the far right of the picture – was originally a small house. The Old Swan Inn is owned today by Marston's brewery. Eric Banks is proud to manage this pub. It is full of charming and historic character. Oak doors are finished with furnishings of brass latch door handles and the low, black ceiling beams add to the authenticity of this traditional English hostelry.

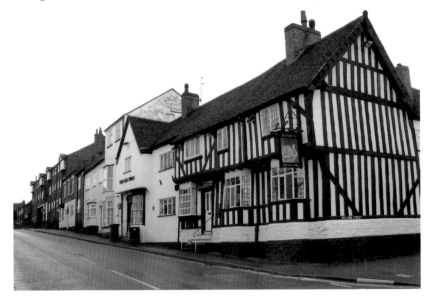

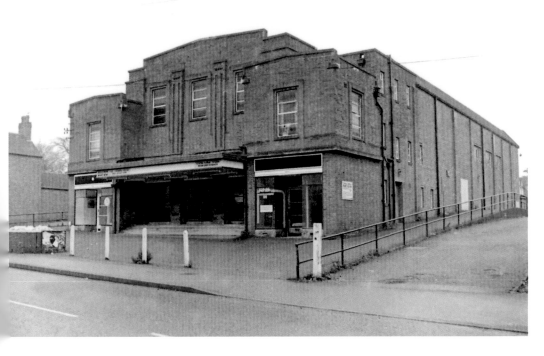

Regal Cinema, 1988
The Regal Cinema opened its doors on the 28 August 1937 and was built on the site of the old workhouse on Long Street. It was demolished in 1932. The Regal Cinema was a modern feature in the town. It had stood for more than fifty years before being demolished in 1988, making way for the modern housing development of Regal Court.

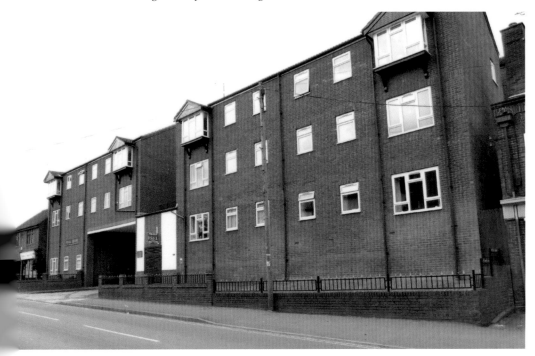

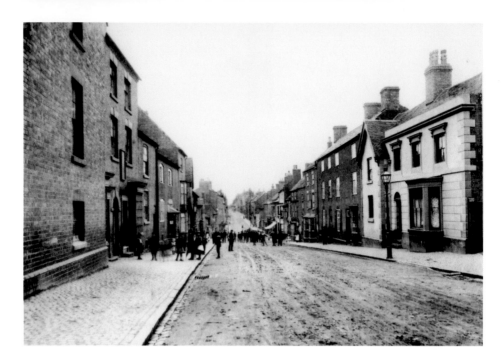

Long Street, c. 1900
The building on the near left is the Workhouse, built following the Poor Law Amendment Act of 1723. Children are playing a game in the main street on the muddy road surface. According to *Kelly's Directory of Warwickshire*, 1880, the mile-long Watling Street (now Long Street) was excavated in 1868 in order to lay down a drainage system at a depth of between 2 and 7 feet. Large Roman paving stones were found everywhere; some were cemented together with the grooves for the chariot wheels. Above the Roman Road was another road that had been roughly constructed. Coins from the reigns of Queen Anne and Queen Elizabeth I were found.

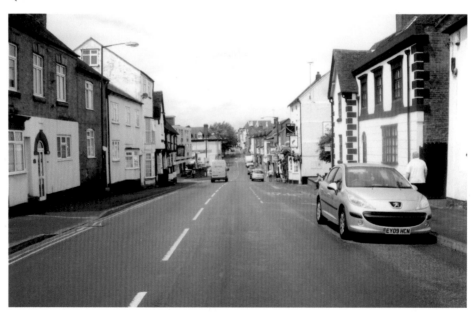

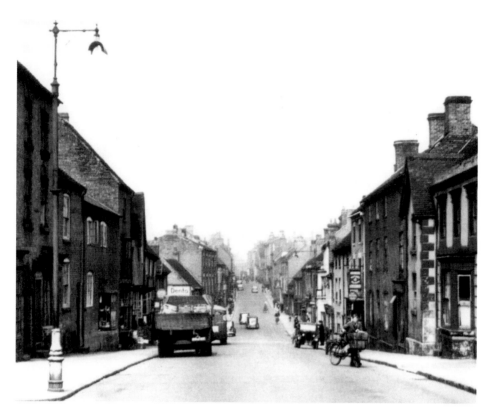

Long Street, 1950s

This photograph was taken in the 1950s before the A5 bypass was built. The town centre was busy with two-way traffic, including lorries transporting goods to their destinations, en route through the town's main thoroughfare. The large building on the far left of the picture is F. J. Elliott Tannery Works. The tannery works stood where Wainwright's Atherstone Garage is now situated.

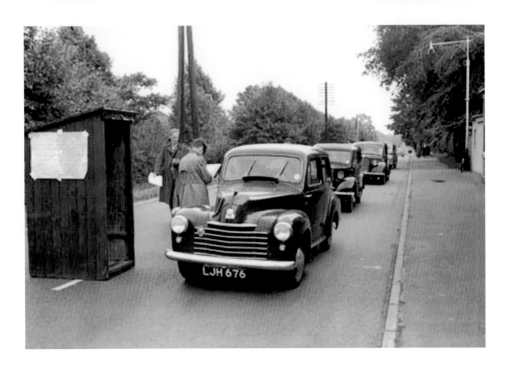

Road Traffic Census, 1951
Traffic census data was being collected at this stop on Watling Street in Atherstone in 1951, in connection with the scheme for a new bypass. The coloured photograph shows the entrance coming into the town on Watling Street as it is today. The road leading off to the left is 'Old Watling Street' and takes you under the cattle arch. This is where farmers once walked into the town with their droves of cattle, en route to the cattle market in Station Street. (W.C.R.O. PH (N),882/181)

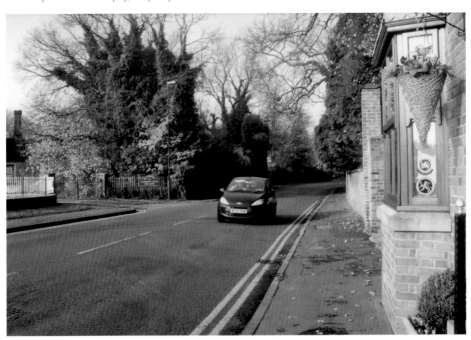

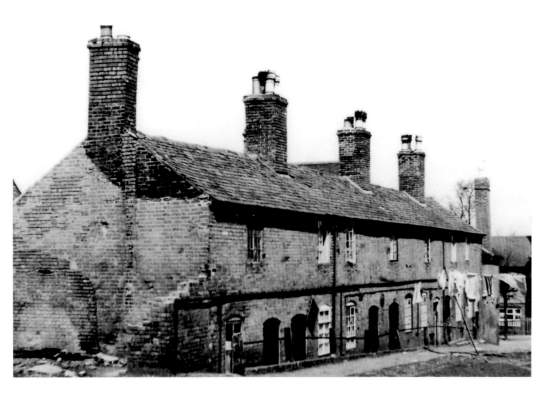

Cotton Mill Yard, *c.* 1950
Cotton Mill Yard was situated next to the Dolphin Inn on Long Street. The Yard was demolished in 1957/58. There was a tale told many years ago that someone ran upstairs into a house in the Yard with the Shrove Tuesday ball. Realising that the other competitors were following, he leapt out of an upstairs window, still holding the ball! The Atherstone Scout Hut has been built on the site of Cotton Mill Yard. (W.C.R.O. PH 1035/C9109)

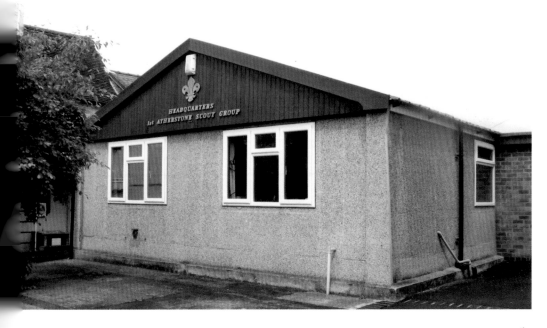

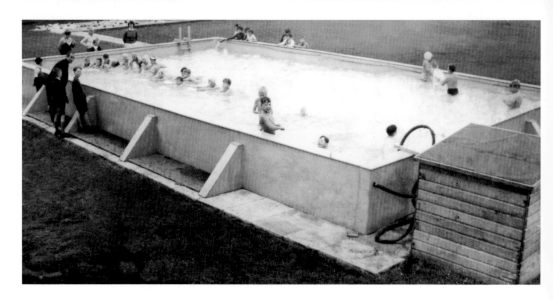

The New Atherstone Guide Hut, Official Opening, 1970s
The new guide hut had been built in the 1970s on the site of Atherstone Swimming Baths – then locally nicknamed 'The Duck Pond'. The original wooden guide hut, which used to be situated next to Sale & Son seed and corn merchants in South Street, became dated and was dismantled. The swimming bath in the picture is not the Atherstone swimming bath, but there are many similarities in design and size. Children were thrilled in the 1960s that Atherstone had its own outdoor swimming bath.

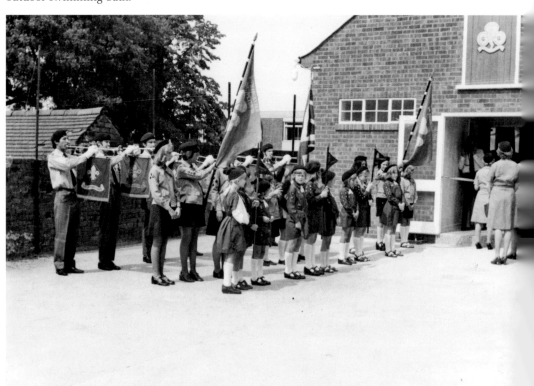

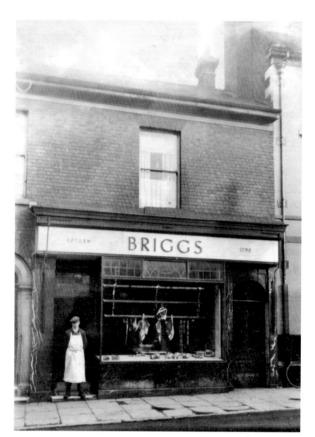

Briggs' Butcher's, 150 Long Street, c. 1920
According to *Kelly's Directory of Warwickshire*, 1928, Walter Briggs traded as a pork butcher at 150 Long Street. Fox's butcher was what the shop was known as from the 1950s up to the 1970s. Fox's had an abattoir at the back of the shop. Today, the shop is a Chinese restaurant and takeaway named the Oriental Chef.

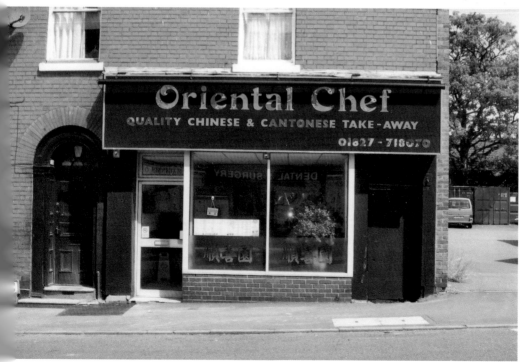

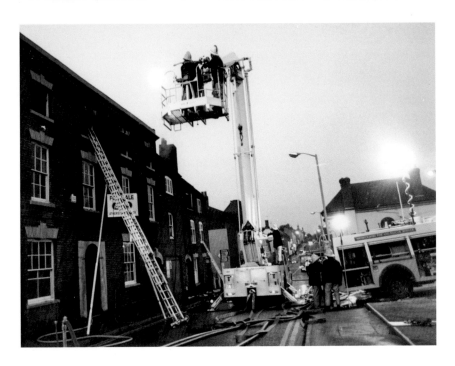

Denham & Hargrave Hat Factory

The hat factory workshops started at the front of Long Street and went back as far as North Street. At the front of Long Street the factory continued down as far as the Hat and Beaver public house. In 1987 a fire broke out, causing extensive damage to the buildings. Denham House, 120 Long Street, was revamped and is now used as offices. A company called 'Invalift' have offices upstairs. The offices downstairs are occupied by a company called 'SocEnv' who help with the challenges posed by climate change. Chartered environmentalists include academics, consultants, utilities managers, engineers and scientists.

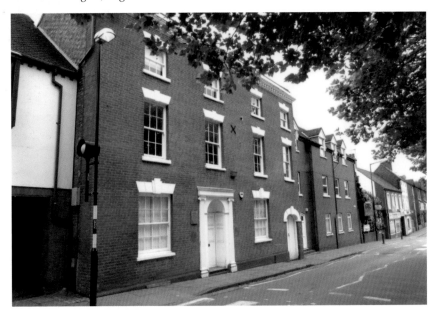

Atherstone Police Station, 1964
Atherstone police station was an early eighteenth-century building, demolished in the late 1960s. On 24 June 1966, Mr R. J. Hughes, magistrate clerk, told an *Atherstone Observer* reporter that, 'the present court premises were antiquated. They were badly heated in the winter, the office accommodation left a lot to be desired and the toilet facilities were very bad.' Ratcliffe Road was widened with Warwick House and Lloyds Pharmacy replacing the old police station and Atherstone's Picturedrome cinema. (0133)

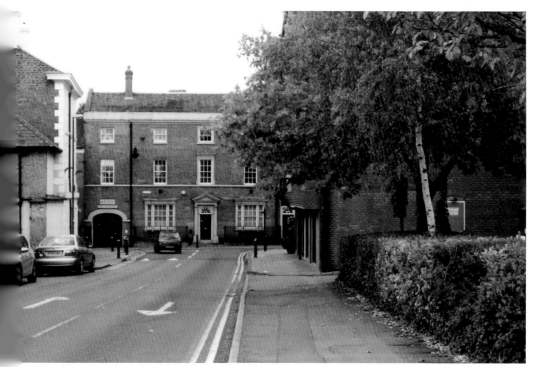

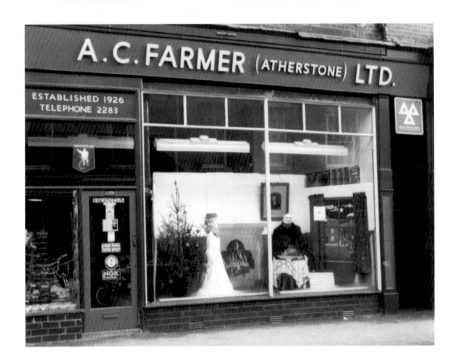

A. C. Farmer, *c.* 1994

A. C. Farmer's bicycle shop was established in 1926. The shop sold many brands of bicycle and scooter. Mr Farmer was also a repairer of bikes and sold the famous 'puncture repair outfit' – rubber patches, glue and chalk for mending inner tubes, sold in a little tin. They were very popular with the boys who were frequently mending their punctures. Farmer's had a Christmas Club every year, and parents could pay an amount of money each week up until Christmas for their child's bike or scooter. Mr Farmer would keep the bicycles at his premises until Christmas Eve. The shop window display was done for one of the town's first 'Dickens Nights' about twenty years ago. Today the shop is known as Keri Ann's, selling beauty products and toiletries.

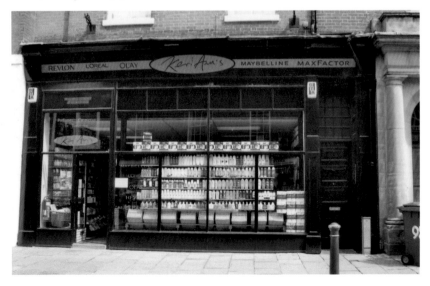

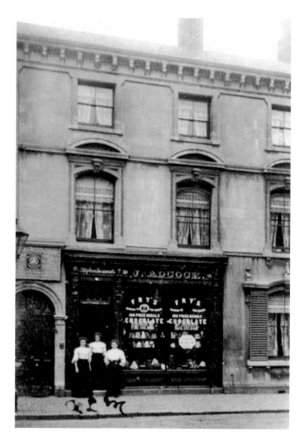

Adcock's Bakery, 1909

Adcock's bakery traded for many years on these premises, selling fresh bread and cakes that were baked in the rear of the shop. Adcock's were also in the business of catering. They hired out a private function room for weddings and other special occasions. The premises is now named The Old Bakery and trades as a café serving meals including breakfast and afternoon tea. (W.C.R.O. PH 352/14/68)

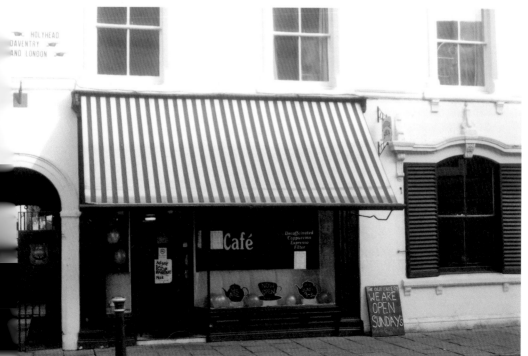

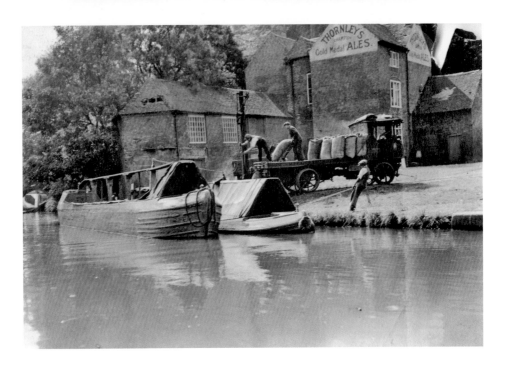

The King's Head, *c.* 1930

Workmen are seen here unloading sacks of corn from the steam wagon onto the barges, ready for transporting along the canal to the next destination. The King's Head public house in this picture has no similarities to the King's Head built in the 1960s. Claire and Jim Donaldson have been landlady and landlord of the King's Head since 2002. There are many boat and barge visitors throughout the year who call at this popular, pretty canalside pub. Locals love to sit outside having a drink or to eat a meal with friends and family in summer. In the winter months there is a log fire burning, with comfy armchairs to sit and relax in while chatting with the locals. The King's Head public house caters for private functions and family celebrations.

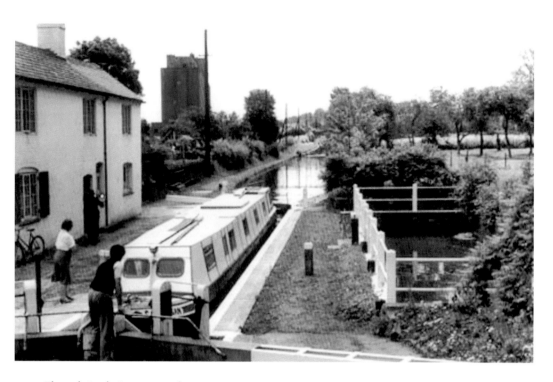

The 5th Lock Cottage, 1960s

Boats and barges have travelled these waters for over 200 years – for transporting goods or just for pleasure. The 5th Lock Cottage stands as it did back in the 1960s – surrounded by pretty woodlands. (W.C.R.O. PH 599/71)

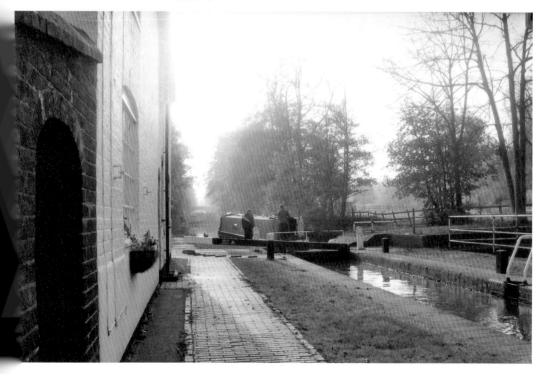

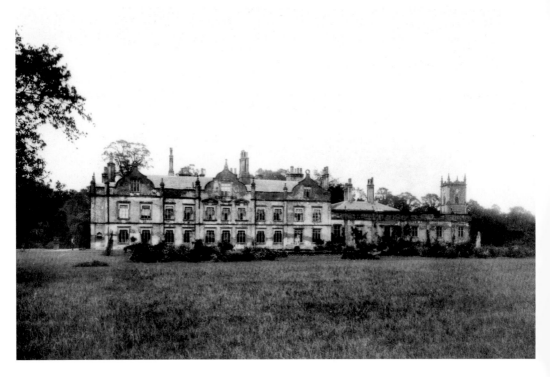

Grendon Hall, *c.* 1930

Grendon Hall was situated on Farm Lane in 'old' Grendon, a rural area about two miles from Atherstone. Grendon Hall was demolished in 1933. There are several structures of age which remain, notably the bridge over the River Anker dating back to 1633. The old servants' quarters is a residential property and several old barns and stable buildings have also been converted into residential properties. It is said that King Edward VIII used to visit Grendon Hall when he was Prince of Wales.

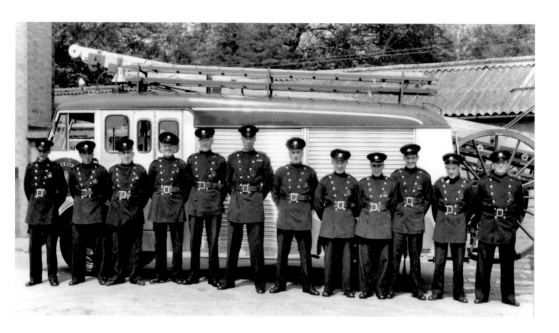

Warwick County Fire Brigade, Atherstone B.6., 1947

This photograph was taken when the new Fire Station had been built in Kings Avenue and Ratcliffe Road. Left to right are: George Lapworth, Henry Hall, Frank Gudger, Percy Gudger, Sid Pratt, Mr Green, Joe Leonard, –?–, Vic Prowse, Bill Pavitt, –?–, –?–. In previous years the Fire Station was situated in Long Street next to the Tannery Works (where Wainwright's Garage was) and before that the Fire Station was at the Market Town Hall. The Fire Brigade's claim to fame is that Mr Green, in the photograph, is the father of Andy Green, who holds the World Land Speed Record, and was the first person to break the sound barrier. Left to Right for the Remembrance Day parade are: Scott Barter, Paul Turner, Matt Baker, Steve Sweet, Derek Holt, Brian Douglas, Kirk Kellegher, Matt Pardoe, Colin Smith.

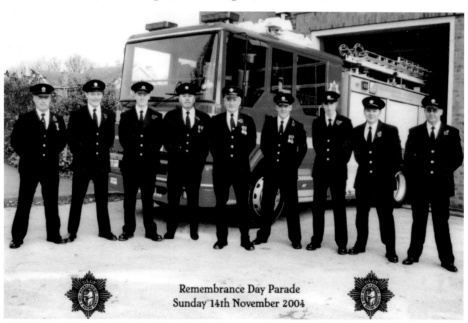

Remembrance Day Parade
Sunday 14th November 2004

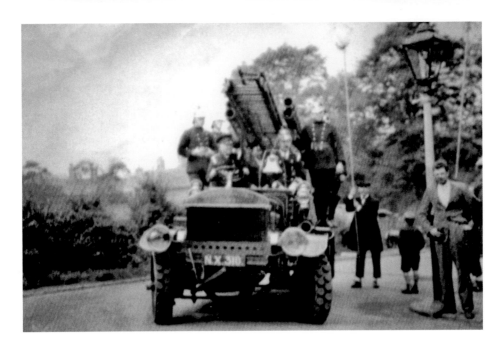

Atherstone Rural District Fire Brigade, 1930s

The fire engine in the photograph is the same one as the one used in 1947. The people look delighted to see the engine and crew, including the street-lamplighter on the right. When the Second World War broke out, the rural district fire brigades were amalgamated into the National Fire Service. The Fire Service was handed back to County Councils under the Fire Services Act 1948. Atherstone became the Warwick County Fire Brigade B.6. During the 1980s the Fire Brigade changed to The Warwickshire Fire & Rescue Services.

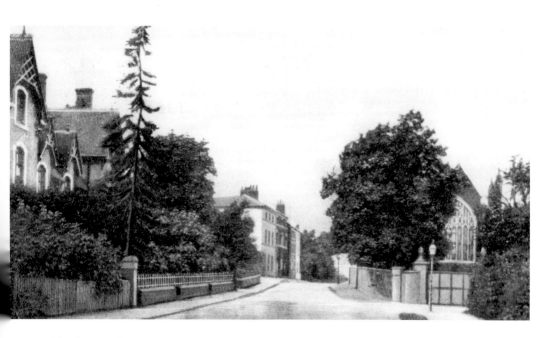

Witherley Road, *c.* 1910

Witherley Road, a few yards before the brow of the town's main mile-long thoroughfare, Long Street. The junction to the right is in front of The Queen Elizabeth Grammar School, which opened in 1864. During the 1970s both the Grammar School and Atherstone High School became a single comprehensive school, The Queen Elizabeth School. The Grammar School is called the 'upper' and the High School is called the 'lower'. Recently the school has been re-named Queen Elizabeth School and Sports College.

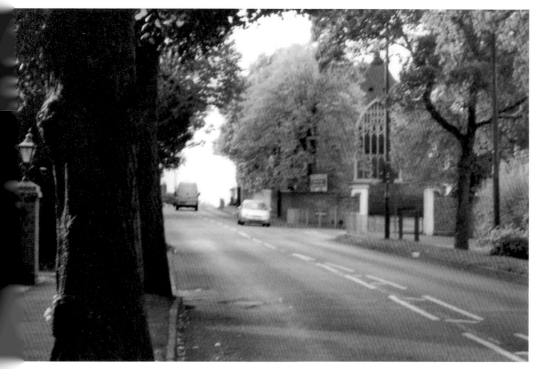

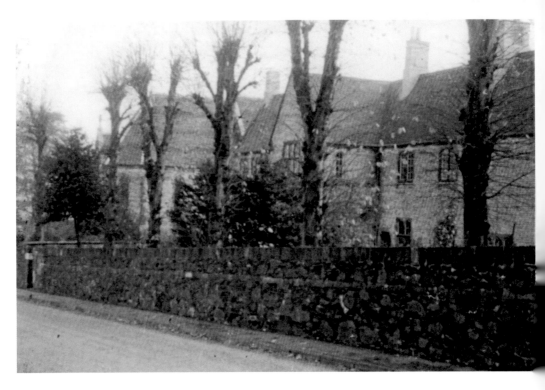

St Scholastica's Convent, 1967, Front View

The convent was built in 1837 for Dominican nuns. In 1859 the convent was sold, and Benedictine nuns from Colwich, Stafford, took over, renaming the convent St Scholastica. In 1967 the Benedictine nuns returned to Colwich and the convent and estate were sold to a private housing developer, who used the land for new housing on Convent Lane and Witherley Road.

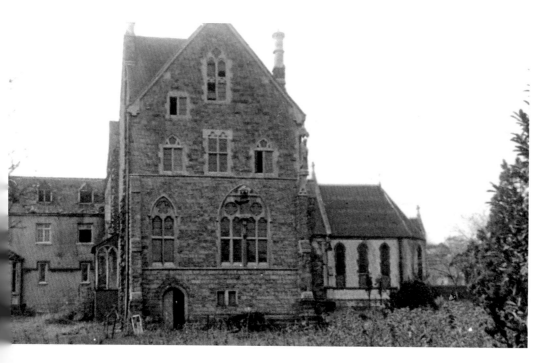

St Scholastica's Convent, 1967, Rear View

The convent had been extended over time and was a fascinating building to view before it was finally demolished. The nuns sold produce to the public. A bell was attached to a serving hatch and the purchaser would place a basket with a shopping list inside, with the payment. A nun would put the items in the basket and place it back into the serving hatch. The *cul-de-sac* built at the rear of where the convent stood is named Convent Close.

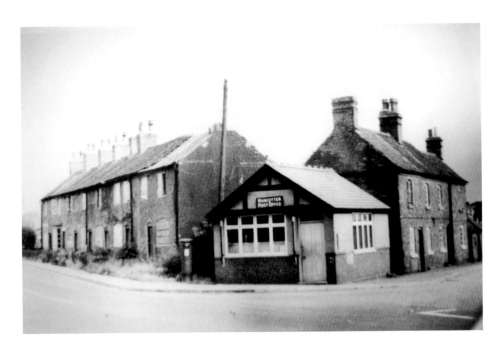

Mancetter Post Office, *c.* 1956

The old post office on Mancetter Road was demolished to make way for detached bungalows and houses, built on the corner of Mancetter Road and Harpers Lane. Harpers Lane starts from the corner shown at the junction and continues down the road onto the A5 junction. A similar post office was built at Mancetter in Manor Road.

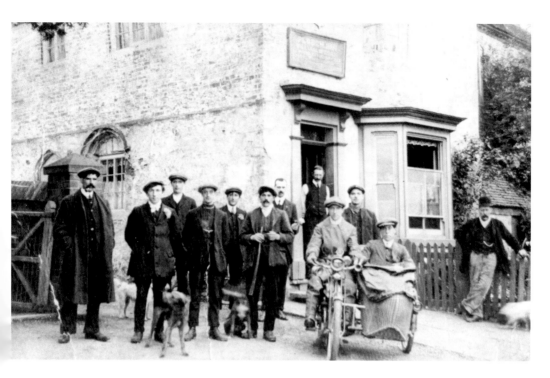

The Plough Inn, Mancetter, *c.* 1910

The Plough Inn has been extended over the years since this early photograph was taken. According to M. J. Alexander and J. L. Slater, 1992, the motorcycle and sidecar in the picture was owned by the Murray brothers, who used it regularly to take their mother from her house, by the Iron Bridge at Hartshill, into Atherstone for her shopping. The landlord is standing in the doorway and is believed to be Mr McKewin.

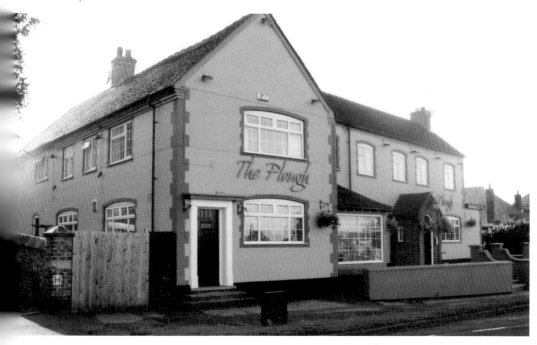

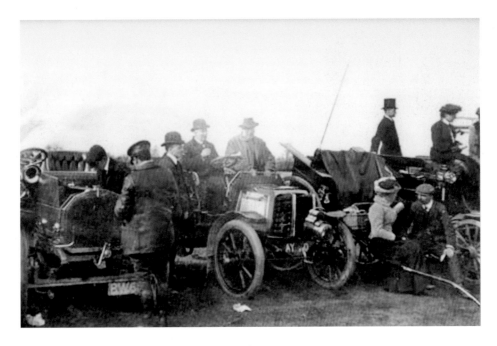

Atherstone Hunt Meeting – 'On the Course', 1905
Spectators sit in their classy, modern cars of the day to watch the Atherstone Hunt on the course, in 1905. Nowadays, 'modern' vintage cars such as these are greatly admired by thousands of car enthusiasts who attend Atherstone's Heritage Motor Show. The organisers exhibit dozens of classic vehicles every year in the Market Square. The 2011 picture shows people looking around a very rare 'Crossley' vintage car, in Church Street. (W.C.R.O. PH,352/215/59)

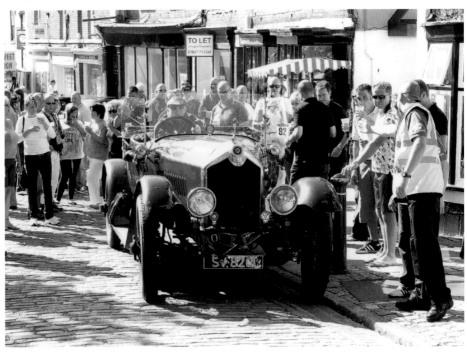

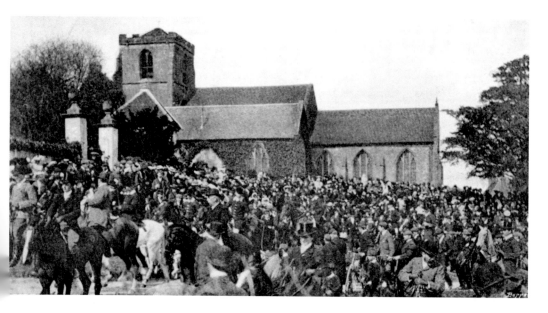

The Atherstone Hunt, St Peter's Church, Mancetter, *c.* 1933

The Atherstone Hunt met on the Green in front of the Mancetter Manor House and Mancetter Church around 1933. The Atherstone Hunt was founded in 1815 by George Osborne of Stowe, who resided in a very large house in Long Street that is now known as the Conservative Club. The Atherstone Hunt had started with just a few local gentlemen meeting up with their packs of hounds to go foxhunting. Almost 200 years on and the Atherstone Hunt still continues to meet in Atherstone and Market Bosworth on alternate New Year's Days. St Peter's Church at Mancetter in the background was assigned in 1196 and stands on a small hill overlooking the River Anker towards the neighbouring village of Witherley. In the main it is a fourteenth-century church with signs of seventeenth-century building work.

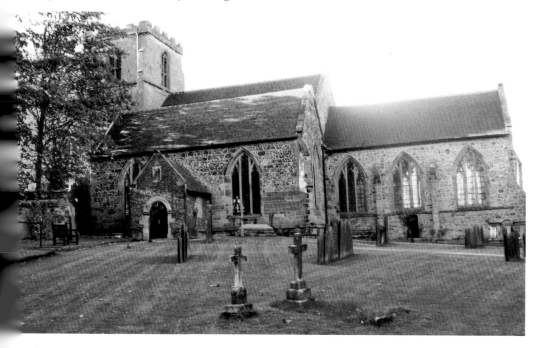

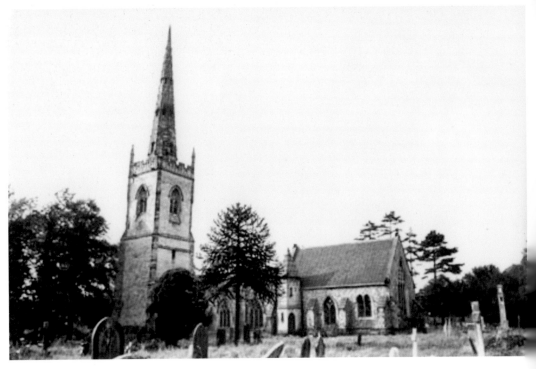

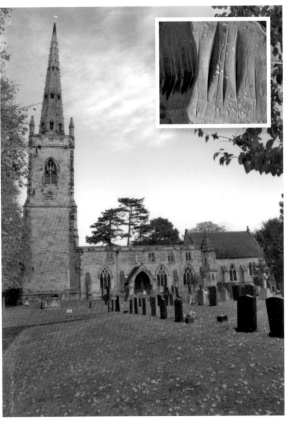

The Parish Church of Witherley and Churchyard, 1950s

The Parish Church of Witherley dates from as early as the fourteenth century and the tower from the fifteenth century. The chancel was rebuilt in 1858. The church is sited in a pretty location next to the River Anker. According to folklore, Richard III sharpened his sword on the arched stone doorway of Witherley Church in August 1485.

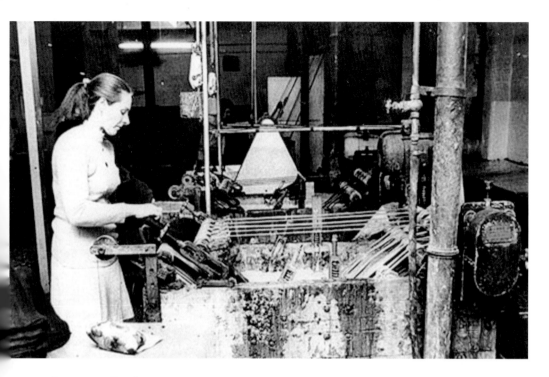

Wilson & Stafford's Hat Factory, 1950s

Mrs Grace Ambrose is seen here in the photograph, working in the proof department in the 1950s. Wilson & Stafford's hat factory closed in the 1990s. The hat factory buildings are still there, although now in a dilapidated condition (2011).

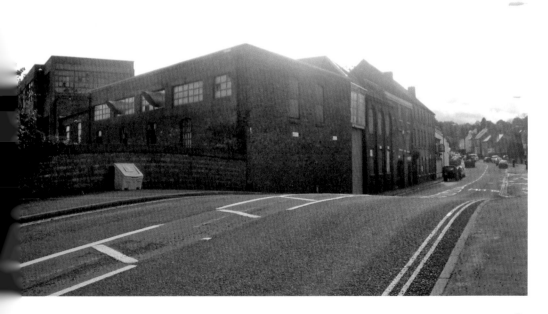

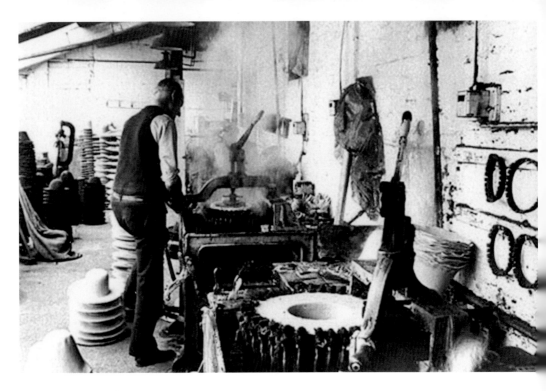

Wilson & Stafford's Hat Factory, 1950s
Mr Dick Evans is believed to be the man in this photograph, working in the shaping department at Wilson & Stafford's in the 1950s. The canalside view photograph of Wilson & Stafford's was taken in 2011.

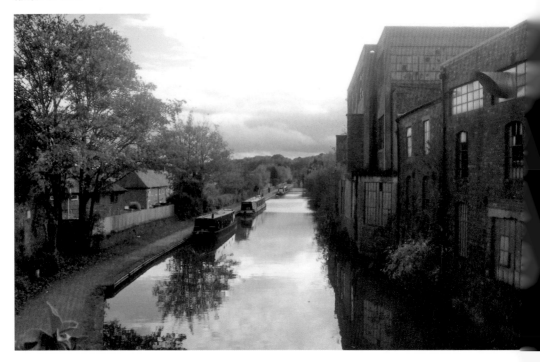

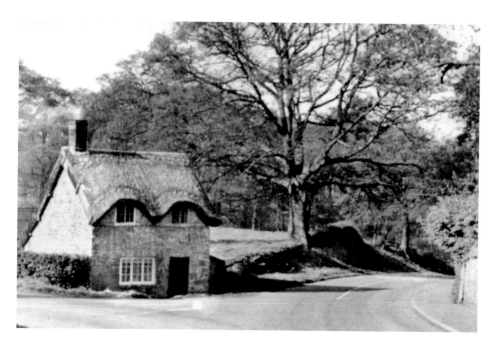

The Toll Cottage, *c.* 1930

The Toll Cottage at Bentley stood at the junction of Ridge Lane and Coleshill Road. It was condemned as unfit for human habitation by Atherstone Rural District Council in the 1940s and was demolished. The men and women who collected the tolls lived in cottages like this during the turnpike systems. The Turnpike Trust began in 1762. Money on the toll roads was collected from travellers using the roads in and out of town. A few shillings a week was earned, with an allowance for coal and candles. A percentage of the money was used for maintaining the roads. 1837 was a peak year throughout the country for toll receipts. However, the coming of the railways, bringing speedier journeys, had a disastrous effect on the toll roads, as goods and passengers were transported by rail. By 1875 the gates and toll bars were being dismantled one by one, and the Turnpike Trust was wound down.

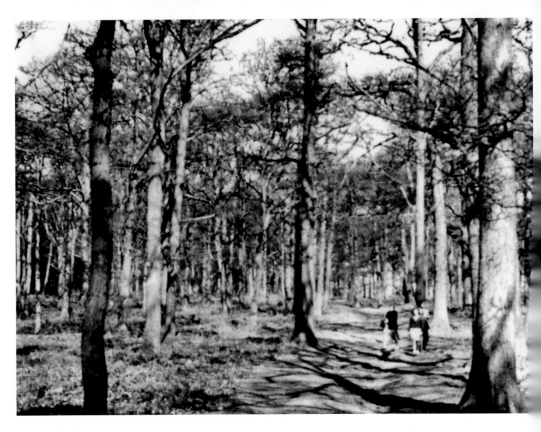

Monks Wood Bluebell Wood, c. 1940
Monks Wood is the bluebell wood at Bentley and has been an attraction for both tourists and locals for generations. The family in the 1940s photograph are unknown. The little girl in the colour photograph is Emma Allitt.

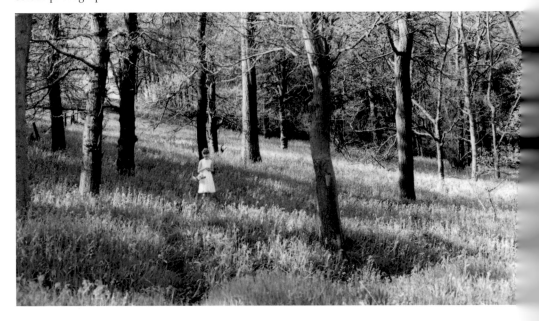

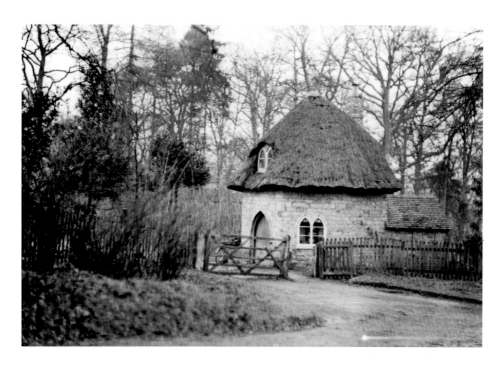

The Beehive Cottage, *c.* 1950

The Beehive Cottage, unlike the Toll Cottage, was saved from demolition in 1961, after an architectural alteration that satisfied Atherstone Rural District Council. The sanitary inspector from the Council, ruled that the ceiling heights did not comply with the 7 feet 6 inches guideline for living rooms and the 6 feet 8 inches guideline for bedrooms. In all, about fifteen of the seventeen picturesque cottages on the Dugdale Estate were demolished by the Council. Clusters of bluebells adorn the woods where the Beehive Cottage stands. Local strollers, tourists, and motorists alike are fortunate to see this unusual, pretty cottage on their travels.

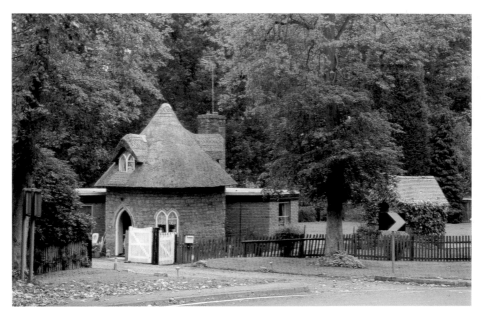

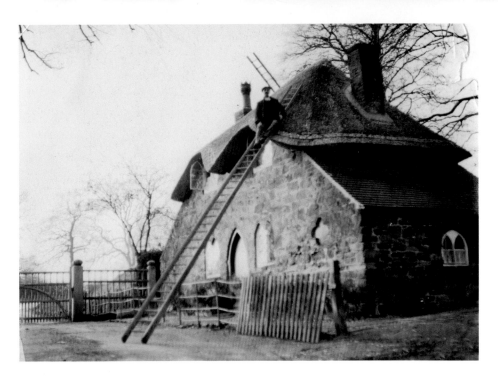

The Top Lodge Cottage, *c.* 1930

Levi Fisher is believed to be the thatcher on the roof of the cottage. The Top Lodge Cottage was another of fifteen picturesque cottages demolished by the Council. Living in the house that replaced the thatched cottage today is the Head Gamekeeper of the Merevale Estate, Jason Douglas.

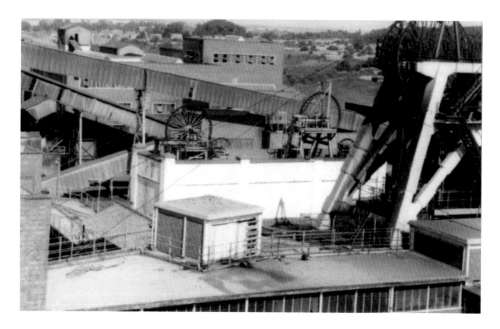

Baddesley Colliery, 1988

Baddesley Colliery was founded by the Dugdale family of Merevale Hall in 1839. On 1 May 1882 eight men and a boy were trapped on the pit bottom of the old workings after a mine explosion; they remain entombed there to this day. Twenty-three others sadly lost their lives in a heroic rescue attempt during the tragedy. The picture shows the colliery producing coal just before its closure on 3 March 1989. The 'old' pit on the left of the picture shows winders nos 1 and 2. The new pit on the right of the picture shows winder no. 3. The pit was the oldest pit in North Warwickshire. The 'old' pit had opened in 1839 with the first mine shaft being sunk in 1850. British Coal said that 'they had no option but to close the pit which had been losing £300,000 a week since June 1988'. The photograph below was taken of coal miners at Baddesley Colliery in the 1950s.

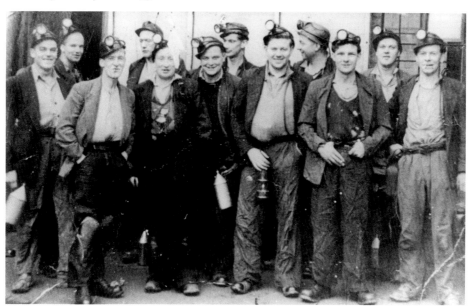

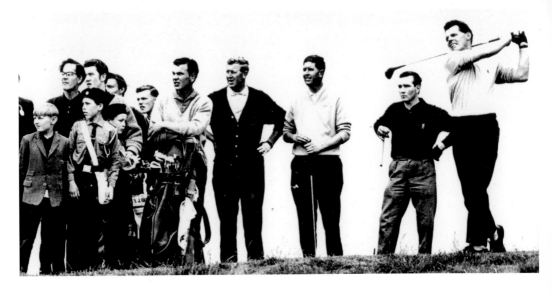

Atherstone Golf Club Exhibition Match, 1965

Pictured here at the Atherstone Golf Club Exhibition Match in 1965 are golfers Bernard Hunt, Geoff Hunt, Ronnie Hiatt and Mike Skerritt. The fair-haired spectator, second from the left is John Webster. In 2010/2011, charity events were organised by Atherstone Golf Club Captain Geoff Freeman and Ladies' Captain Ann Randall in support of the Help for Heroes. On 3 October 2011 golfers from all over the region played in a Charity Competition for Help for Heroes. Some of the golfers who took part that day are pictured here: Wayne Pardoe (Swindon Golf Club), David Pearson (Halesowen Golf Club), Paul Broadhurst (European Professional Golfer), Geoff Freeman (Captain, Atherstone Golf Club), and Kelvin Jones (Bridgenorth Golf Club).

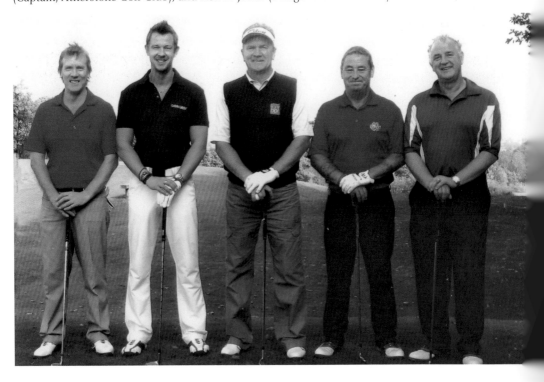

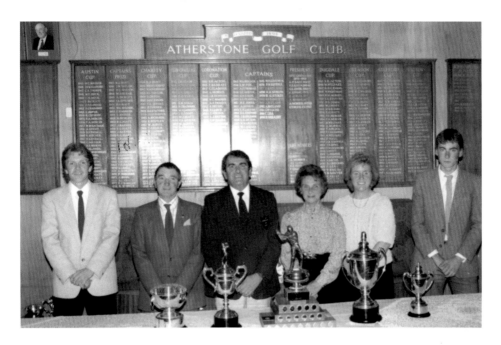

Atherstone Golf Club, 1987

The Atherstone Golf Club took all five trophies in the inter-club competition between Atherstone, Hinckley and Nuneaton in 1987. Left to Right: Paul Broadhurst, Ronnie Hiatt, Bill Whitmore (Captain), June Parnell (Ladies' Captain) and Jane Burgess. In 2011 Geoff Freeman (Men's Captain) and Ann Randall (Ladies' Captain) were photographed here sharing a proud moment when Atherstone Golf Club had won four of the five trophies available in 1987: The Chadaway Cup (Juniors), the Jarvis Trophy, the Hodge Trophy and the Observer Trophy (not shown).

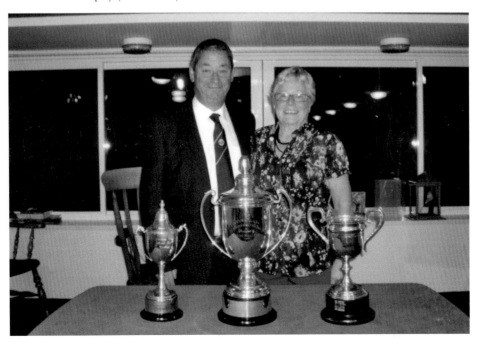

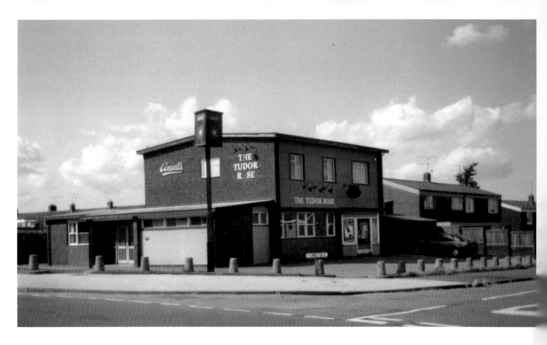

The Tudor Rose, c. 1970
The Tudor Rose was built on St Georges Road and opened around 1964. The Tudor Rose prospered for a number of years under the management of Fred and Phyllis Payne. Alan and Sylvia Walker successfully managed the pub too, until their retirement in 1992. After this, a number of temporary managers attempted to run the pub but business and social activities declined. Following this, in 1998, the Tudor Rose closed down and was later demolished, making way for new houses to be built on the site.

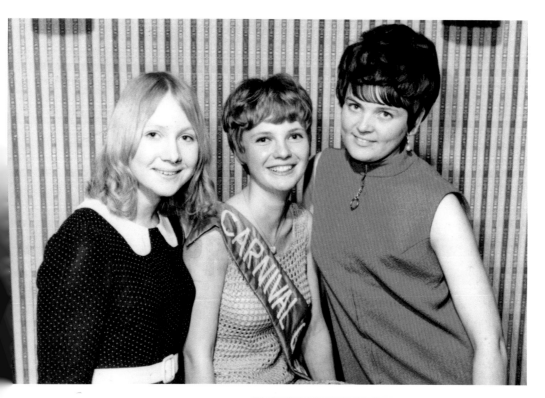

Atherstone Carnival Queen and Maids of Honour, 15 June 1968
Wendy Smith (centre), with Maids Janet Cushing (left) and Brenda Holland (right). All three girls were from Sheepy Magna. The annual dance to select the Carnival Queen and her Maids took place at Atherstone Memorial Hall and was judged on the same night. It has always been customary for the crowning of the Carnival Queen to take place in the 'back way' (Station Street) or in Market Square. Danielle Basford was crowned Atherstone's Carnival Queen in 2011.

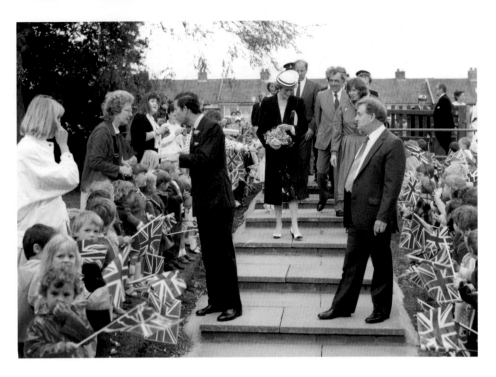

Royal Visit to Atherstone Nursery School, 1985

Prince Charles stops to have a word with Nursery Teacher Mrs Rushton on the steps leading to the front of the school. Mr Butcher who was the Headmaster at Racemeadow Primary School is standing on the right of Prince Charles. The nursery school was originally built during the Second World War, so that married women with toddlers and babies could go to work in the munitions factories. The nursery school was demolished in 2005. The early learning centre has been built on the site with the new nursery school being built close by.

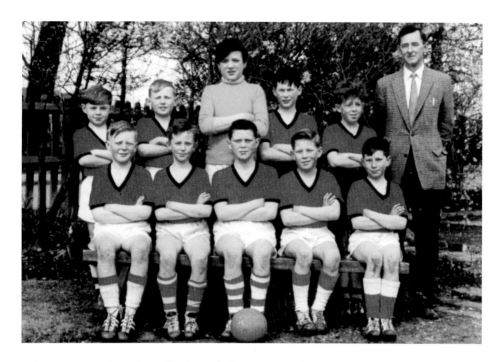

Atherstone North Junior School Football Team, 1963/64
Back Row: John Smalley, John Webster, Martin Murphy, Richard Batty, Paul Reardon and Teacher Mr Snooks. Front Row: Robert Fletcher, David Lees, Des Shilton, Stephen Reardon, David Brotherhood. Atherstone North Junior School and Infants School buildings are situated in Ratcliffe Road. The Atherstone Youth Community Centre is based in the old school building, while Atherstone College was built on the site of the Headmaster's office, dining room, and two other modern classrooms. Ratcliffe Road Doctors' Surgery was built on the school playing field. A brand new primary school was built for pupils to attend in the late 1960s, named Racemeadow School.

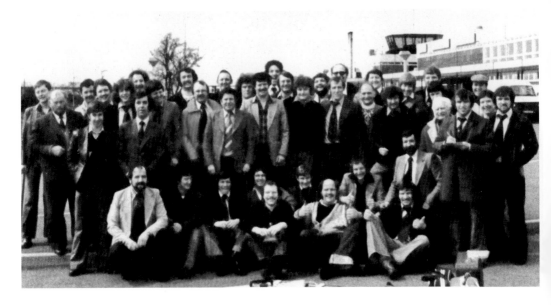

Atherstone RFC, Ireland Tour, Limerick, 1979
Front Row: A. Richardson, N. O'Brien, J. Hughes, T. Rigby, D. Webster, R. Teagles, C. Bell, R. Clamp, M. Carty, R. Smith. Second Row: B. Pratt, P. Hanlon, C. Ludford, P. Carter, J. Aherne, V. McCabe, J. Lewis, I. Linstead, H. Harding, D. Rickalans, C. Aherne, D. Brain, P. Ward, J. Yeomans. Third Row: K. Matthews, D. Boal, G. Frost, P. Burton, D. Aherne, C. Bambrook, R. Davis, B. Horton, W. Aherne. Back Row: A. Allan-Stubbs, B. Daniel, R. Dolphin, J. Clarke, S. Barlow, G. Barnett, T. Murphy, R. Kitchen, A. Matterson. Below, Atherstone RFC 1st and 2nd Team 2011 are photographed on the Atherstone Rugby pitch.

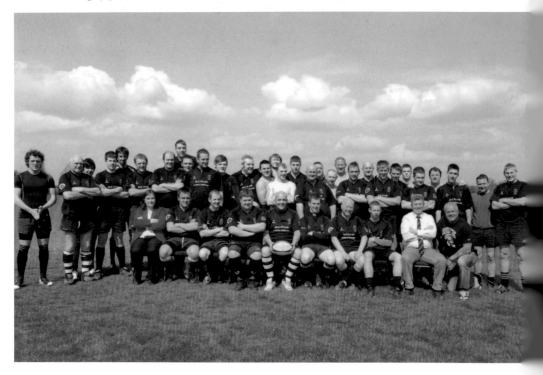

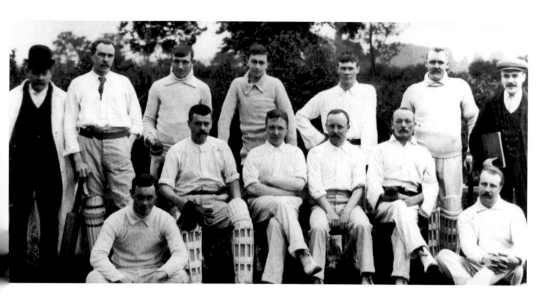

Atherstone Town Cricket Club, 1907

Front Row: Len Ireland, Tommy Albrighton, Charlie Joint (Captain), Harry Stafford, The 'Pro', Walter Stafford. Back Row: Umpire, Fred Alcock, Billy Mills, Harry Sale, Jimmy Ireland, Walter Whiteman, score man. Below, Atherstone Town Cricket Club – Coventry & District Cricket Club League Champions 1997. Front Row: Robert Boal, Wahid Zaman 'Pro', Manny Alcock, Steve Healey (Captain), Justin Hadley. Back Row: Richard Perry, Adrian Williams, Mohammed Patel, Simon Grayson, Nick Maling, Vic Clements.

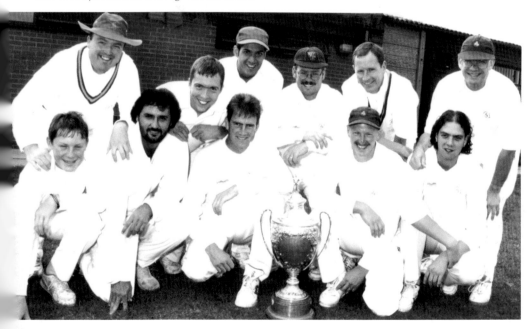

Bibliography

Atherstone Library Archives, *John Edward Compton-Bracebridge, Esq., J.P.* (1910)

Burrow, Edward J., *The Borough Pocket Guide to Atherstone and District*, 39 (1930)

Kelly's Directory of Warwickshire (1880, 1920, 1928 and 1932)

Slater, J.L. et al., *Atherstone: An Outline History of a North Warwickshire Market Town* (1985)

The Church Publishers *The Parish Church of St Mary Magazine* (1960)

Watts, Brenda and Eleanor Winyard, *The History of Atherstone* (1988)